FLIXTON, URMSTON & DAVYHULME

THROUGH TIME

Steven Dickens

AMBERLEY PUBLISHING

This book is dedicated with gratitude to my parents,
John and Barbara Dickens.

First published 2013

Amberley Publishing
The Hill, Stroud, Gloucestershire, GL5 4EP
www.amberley-books.com

Copyright © Steven Dickens, 2013

The right of Steven Dickens to be identified as the
Author of this work has been asserted in accordance with
the Copyrights, Designs and Patents Act 1988.

ISBN 978 1 4456 1507 3 (print)
ISBN 978 1 4456 1516 5 (ebook)

British Library Cataloguing in Publication Data.
A catalogue record for this book is available from the
British Library.

Typesetting by Amberley Publishing.
Printed in Great Britain.

Introduction

Historically, Flixton has always been at the centre of the old parish, with the church of St Michael, established around 1190, at its religious and administrative heart. The origin of the place name Flixton has several potential roots, with David Herbert Langton favouring Fluxton as the most likely origin. 'Flux', meaning 'flowing', relates closely to Flixton's siting at the confluence of the Rivers Mersey and Irwell. Ormes Tun, with 'Tun' meaning 'a dwelling' (hence 'Orme's dwelling'), eventually became Urmston. Orme was the son of Edward Aylward, a relative of the original landowners. Davyhulme is derived from the original landowning family name of Hulme, one-time owners of Davyhulme Hall.

The archaeology of the district notes some significant finds relating to pre-history. The *Transactions of the Lancashire and Cheshire Antiquarian Society* (LCAS) for 1895 tell us that, 'A spear head ... was found in the workings of the Irlam section of the Manchester Ship Canal,' and in the same volume's 'Proceedings', we are told that, 'Mr S. Jackson exhibited the drawing of a stone celt (eleven inches by three and a quarter inches) found in the Ship Canal excavations at Cadishead.' The LCAS proceedings for 1894 also report the discovery of an 'Ancient Boat' in the Manchester Ship Canal excavations. Admittedly, while this particular find was not located in our district, it would bear out the importance of the region's rivers in the lives of our ancient ancestors.

This significant influence has carried on into more recent times, with William Harrison writing in an article for the *Transactions of the LCAS* in 1894 that the three fords located in the district were important for access to parish churches and the avoidance of turnpike road tolls. In 'Flixton and its Church,' published in the *Transactions of the LCAS* in 1887, Daniel John Leech, who was a relative of Sir Bosdin Leech, wrote that, 'The very situation of the place, too, tended to prevent change, for the rivers which surround it on two sides were unbridged and the roads to Flixton led nowhere else ... changes therefore in the ownership of property were comparatively unfrequent.'

Urmston's desire to improve its transport contacts with Manchester and the surrounding suburbs is shown in an article published in the *Manchester Guardian* on 30 January 1905. This reported negotiations for a tramway from Stretford Road to Station Road, and on to Crofts Bank Road. It eventually proved too costly, with Urmston and District never receiving a tramway. It was left to twentieth-century urban expansion along Stretford Road to substantially transform the location, with historic dwellings like Lime Tree Farm giving way to housing at Lime Tree Close, for example.

Today, however, the influence of modern transport has lessened the feeling of isolation. Like the neighbouring district of Sale, the construction of the M62 motorway (now the M60) has significantly altered the overall look of Urmston. This has resulted in the loss of several buildings of historical importance, including Auburn Lodge on Stretford Road, demolished in 1964 and once the home of Mrs Henry (Ellen) Wood, the Victorian novelist, most noted for writing *East Lynne*. Urmston Lodge, known as Pineapple Hall and located at the junction of Stretford Road and Moss Vale Road, was built in 1648 by the de Trafford family and demolished in 1959. On the opposite corner was Highfield House, built in the 1860s. Once the home of Marshall Stevens, one of the founders of the Manchester Ship Canal and Trafford Park

Industrial Estate, the house was demolished around 1948. Named Urmston Grange from 1851, Brook House was built in the late sixteenth or early seventeenth century and was once home to John Tomlinson Hibbert, founder of Urmston's first church schools in 1859. He also supported the establishment of Urmston parish church.

Newcroft Hall did not fall victim to motorway construction, being demolished in 1935 to make way for modern housing. It is mentioned here due to its important place in the history of Urmston – it was originally a seat of the de Trafford family. Hillam Farm was not redeveloped in the initial motorway construction, and it survived until it was progressively demolished for the proposed Carrington Spur Road in 1971, 1986 and 2003, which opened completely in 2006. Road construction has also profoundly affected one of the main historical features of Urmston. Carr's Ditch was initially thought to have been a Roman defensive feature, but research has proved it to be medieval in origin, built to perform the tasks of an administrative boundary between Urmston and Davyhulme and a drainage ditch for surrounding fields. It was eventually obliterated completely when Moorside Road was extended from Crofts Bank Road to the New Curzon Cinema and Bowfell Circle.

Davyhulme was also affected by the construction of the motorway and urban expansion, with Wilderspool Woods standing in the motorway's direct pathway. The woods formed the grounds of Wilderspool House, which remained standing for many years after the establishment of the M62 but now lies beneath the Trafford Centre, opened in 1998.

Flixton, Urmston and Davyhulme have their own unique and instantly recognisable characteristics. Flixton experienced industrial development as early as 1851, with Stott's Mill, close to the Bird i' th' Hand public house on Flixton Road, surviving until 1935/36. Flixton retained some of its rural village identity, resisting much of the 1930s housing boom. However, despite the survival of the village church and several early cottages, much of its centre was lost to redevelopment in 1963. While I initially believed that many of the headstones on the north side of Flixton churchyard were laid flat at this time, it would appear that this was not the case, as borne out by photographs of the early 1900s. Richard Lawson remarked on the churchyard in 1898 that, 'On account of its great age and former mode of irregular laying out of the ground, [it] cannot be said to be pretty, but at any rate it is cared for.'

Today, Urmston is at the economic and social heart of the area, with recent retail development helping to regenerate the town. The parish church of St Clement and the Lord Nelson public house are a reminder of Urmston's importance as a past administrative centre. Much of Davyhulme's development has more recent origins, although some eighteenth- and nineteenth-century farmhouses survive, such as Jaw Bones Cottage on the old Davyhulme Hall Estate. The nineteenth-century Nag's Head public house is also an instantly recognisable focal point. However, the most extensive developments occurred in the housing boom of the 1930s. In 2013, there are still major changes taking place, with Trafford General Hospital's services under threat in the 65th year of the NHS. The country's first NHS hospital has recently lost its midwifery services, with the A&E unit controversially downgraded. What the future holds for this historically unique hospital, only time will tell. Finally, it is hoped that this photograph selection will provide the reader with knowledge of the main changes that have occurred in the district and a deeper understanding of its history and development.

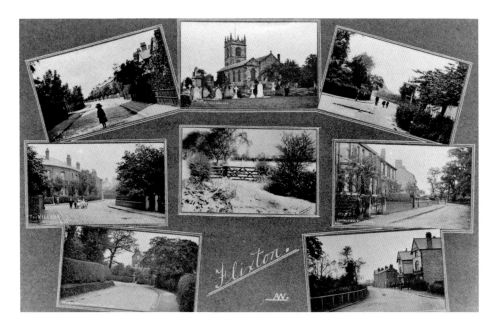

Views of Flixton, 1916

Above are views of Western Road, St Michael's church, Boat Lane, Church Road, Flixton Road, Irlam Road Corner, and winter in Flixton, at the footpath on Western Road. Most of these Flixton views are still recognisable today, despite extensive development around 1930–60. Church, Irlam, Flixton and Western Roads remain residential, with the footpath linking Western Road to Irlam Road now beneath suburban housing. Flixton Road shows two identical properties on the right. The first was a general store and the second, Howarth's Butchers, has been at this location since 1966. Previous butchers included Vernon and Holdsworth. The row alongside these shops, now demolished, was known as Alice Ann Terrace.

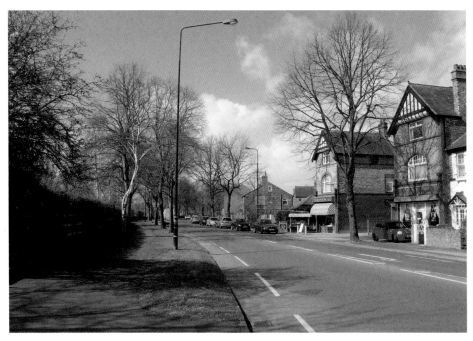

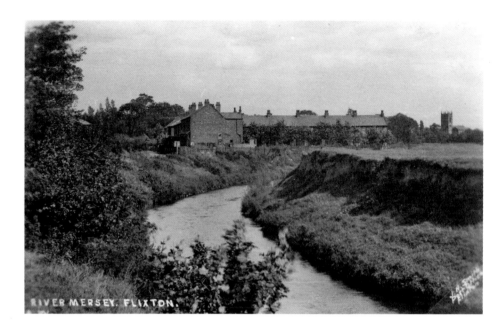

Site of Carrington Bridge, Before 1907, and Footbridge, Carrington Hall Farm, Flixton, 1906
Carrington Bridge, near Morris Grove, is also known as Flixton, Mile Road, or County Bridge. The wooden footbridge of around 1558–1603 was replaced by an iron footbridge around 1840, located where Carrington Road led west from Mersey View, or Four Lane Ends. It crossed the River Mersey close to Carrington Hall Farm (*inset*), allowing the residents of Carrington to attend St Michael's church services. The bridge crossed land known as Treeley, owned by members of the Royle family, who also owned several other properties along Carrington Road.

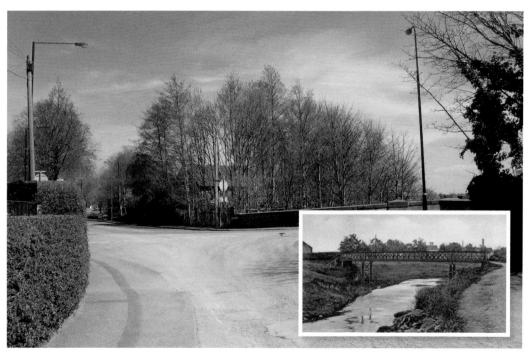

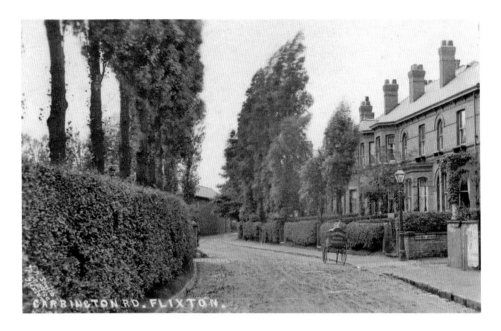

Carrington Road, 1920, and the Old Parsonage, Flixton, 1883

Carrington Road, seen here at the junction with Victoria Avenue in 1920, was much narrower than it is today, having been widened to accommodate motor transport. The tall trees either side of Carrington Road were a local landmark at the time, with the outbuildings of Glebe Farm, now the site of Parker's Garden Centre. Victoria Avenue has since been renamed Hampstead Avenue, and its junction with Carrington Road is the former site of the old parsonage (*inset*), constructed around 1400–1500. The Co-operative building was erected on the adjacent corner in 1928.

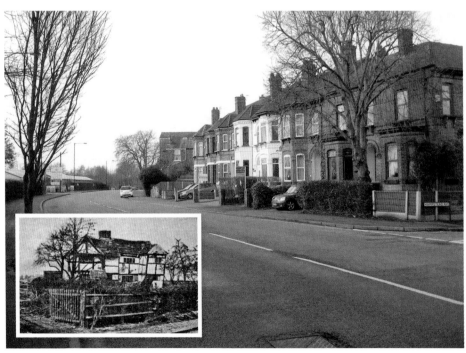

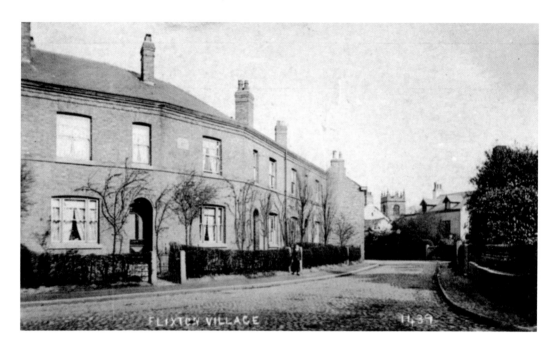

Stocks Terrace, Showing the Greyhound Hotel and St Michael's Church Tower, Flixton, 1913
Stocks Terrace, on Church Road, was erected around 1885 by the Royle family, close to the village stocks, which were dismantled around 1823. Later, this was the site of the Jubilee Tree, planted in 1887. Together with Stocks View and Stocks House, built in 1893 on the site of The Hollies farmhouse, Stocks Terrace formed the junction of Carrington, Church and Flixton Roads, housing eight families. This junction is wider today due to the redevelopment of Flixton village in 1963. Some surviving cottages date to 1672.

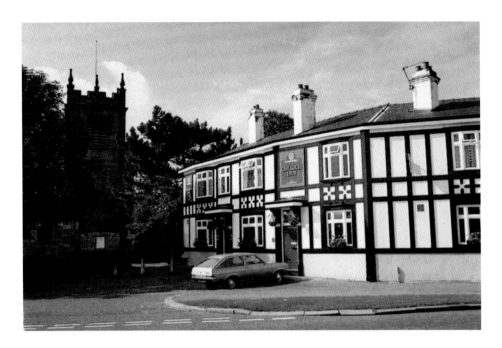

The Church Inn, Flixton, *c.* 1970, and The Greyhound Hotel, Church Road, Flixton, 2013
The present Church Inn dates from 1924, although records begin in 1731. It is believed, from a deed of sale of 1830, to have once been named The Dog and Partridge, sited opposite the current public house. The Squires Wright, Justices of the Peace for the parish, held local courts here, with Sarah Jane Moller as licensee in 1903. The Greyhound Hotel, first licensed in 1788 to James Tong and rebuilt in 1923, is now a restaurant called The Village Inn. John Stott was listed as landlord in *Slater's Directory*, 1903.

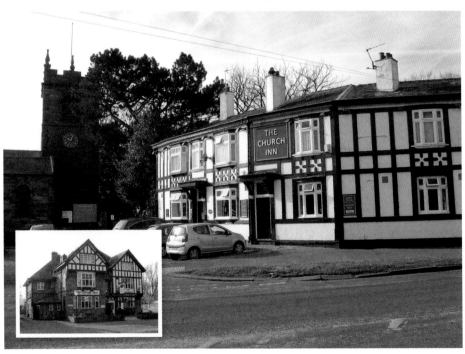

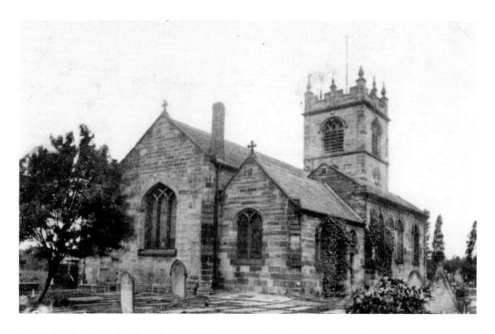

St Michael's Church, Church Road, Flixton, 1908, and Interior, c. 1890

Founded around 1190, St Michael's is a Georgian building of local sandstone. The church was rebuilt in 1756, extended in 1851 and restored in 1877, with Georgian furnishings removed and a stone font, reredos and pulpit, given by the Stott family, installed. The tower, rebuilt 1729/31 and 1888/89, housed eight bells. Its clock faces were donated by Margaret Ellen Newton of Holly House, Irlam Road. The graveyard was enlarged in 1868 and 1887, with the oldest stone marked 'WD 1669' and the largest belonging to the Walkden family.

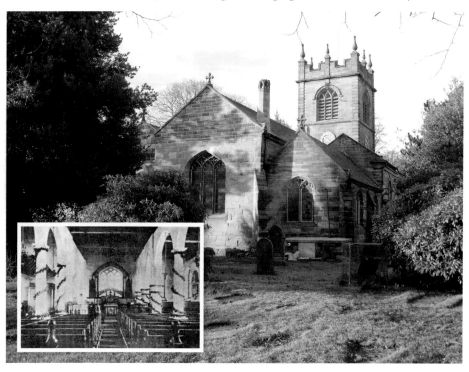

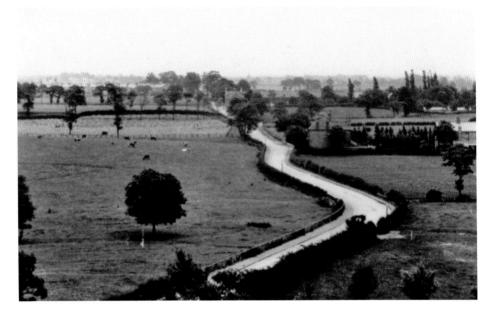

Church Road, Looking East from St Michael's Church Tower, Flixton, 1903

Church Road has been widened, creating a spur where it originally ran in front of
St Michael's church. The modern photograph was taken from the junction of this spur,
looking towards Shawe Hall, from where, Langton believed, a tunnel ran to Flixton church.
On the right can be seen Edgeley Road and the entrance to Shaw Hey Farm, flanked
by two terraced houses, facing Church Road. Opposite was Acre Gate Farm, part of the
Worthington-Wright estate, now the William Wroe golf course.

Carrington Road, Looking West from St Michael's Church Tower, Flixton, 1903
On the left is the River Mersey before the construction of Carrington Bridge in 1907. The terrace in the centre is Morris Grove, with buildings belonging to Glebe Farm to its right and Pool Plat Field opposite. The large Victorian villa on the right is Stocks House, constructed around 1893 on land at Glebe Farm. It was a nursing home for many years and was redeveloped in 2004 as residential apartments called Village Court, which opened in 2007.

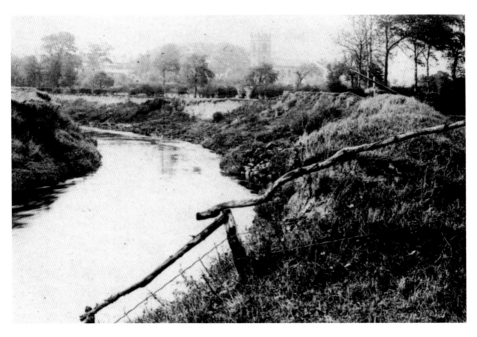

Flixton and St Michael's Church from Shaw Hey, and the River Mersey, 1908
At Shaw Hey there was a culvert diverting floodwater under Church Road at Shey Bridge
and onto fields, which are now the William Wroe golf course. Previous attempts at flood
defence (Mersey is Anglo-Saxon for boundary) show the riverbanks raised and reinforced.
It gives some idea of the height floodwaters could reach, with a series of sluice gates
controlling flooding before the construction of the Manchester Ship Canal. Today, the golf
course is still prone to flooding.

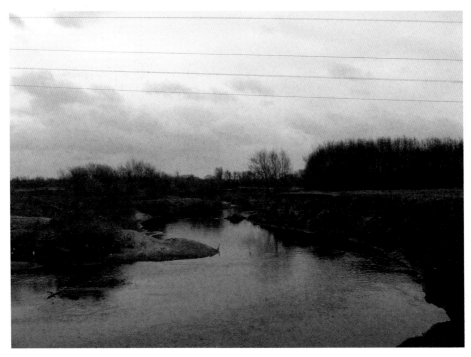

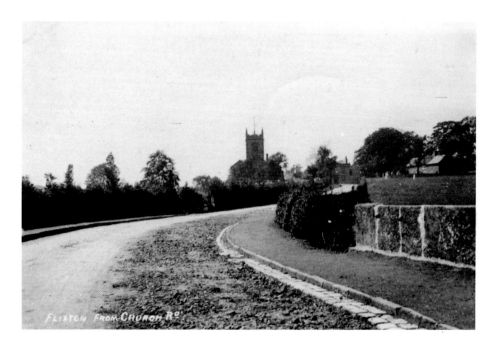

Flixton and St Michael's Church, Church Road, Showing the Original Church Inn, 1908
'Shey' was a corruption of Shaw Hey field, which was drained by a culvert. It was piped in 1953 and the *c.* 1890 stonewalling on the right removed. Shown are School Cottages near the Parochial School, built in 1861 and demolished around 1974. According to *Slater's Directory,* the schoolmaster in 1903 was John D. Wilkie. In January 1959, a new school building was opened on The Grove.

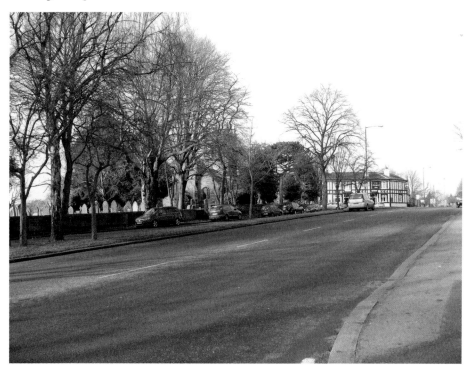

Shawe Hall, Shawe Hall Avenue, Church Road, Flixton, 1908

With its origins in the fourteenth century, Shawe Hall was probably built by the Valentine family sometime after 1305. The first hall was surrounded by a moat, which was planted over in 1847. Shawe Hall was a two-storey building facing Ashton on Mersey, and was built of brick with fifteen gables and a cupola, with the bell removed in 1863. According to Langton, in the early part of the nineteenth century it was a ladies' school and contained tapestries, featuring a Persian chief kneeling to Alexander the Great, and a painted ceiling, featuring Darius kneeling to the same. After 1870, it was divided into two dwellings, and was the home of James Ridehalgh, according to *Slater's Directory* of 1903. It was demolished in 1955.

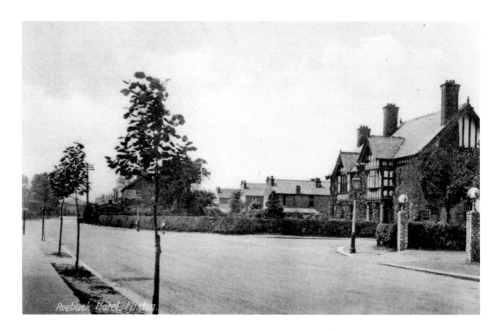

The Roebuck Hotel, Church Road, Flixton, c. 1930

The 'Buck', first licensed in 1788 to Joseph Gilbody, was located in Shaw Town. It has been extended and altered several times, including its original entrance, which opened out onto Chassen Road. It has retained its bowling green, although the original gardens at the front are now a car park. It was the victim of a fire in March 2007, remaining empty with its future undecided until it was refurbished and reopened. It includes a new restaurant among its facilities.

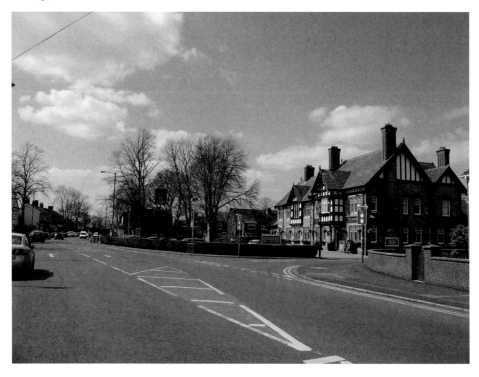

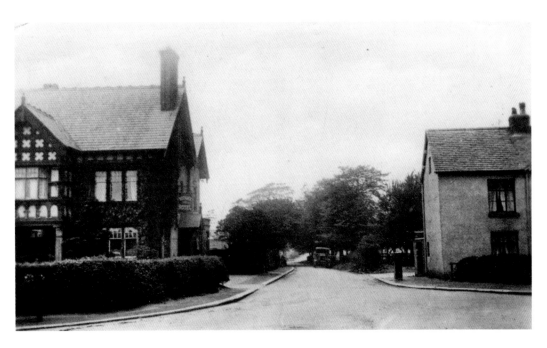

Shaw Town Corner, Junction of Chassen Road and Church Road, Flixton, 1931
Chassen Road was originally named Penny Lane, and Shaw Town Corner was also known as School Green, the first schools in the parish being located here. The cottages on the right were the last remnants of the parish tithe barn and were used for several purposes in the twentieth century, including a garage and the offices of a coach company. The barn was converted into a stable. The corner was sold in 1964 and demolished in the 1990s for residential purposes.

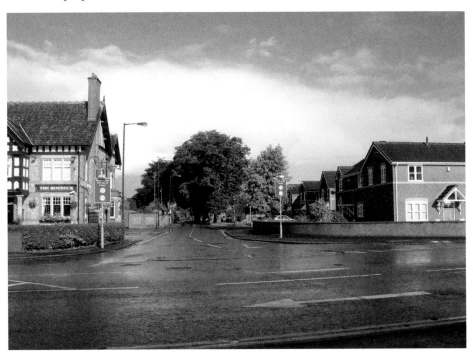

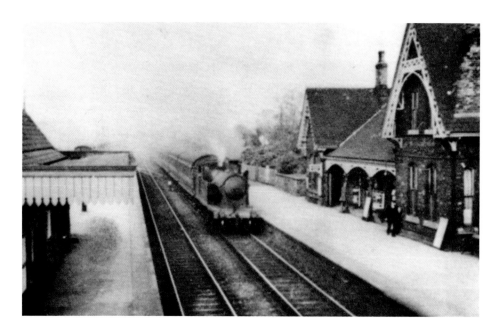

Flixton Railway Station, 1935, and Third-Class Railway Ticket, Issued Before 1956

Opened on 2 September 1873, the station was eventually sold and the southern platform became a restaurant, nightclub and bar. This burnt down in 1998, with the site cleared by 2001. The old goods yard is now a car park, and the footbridge shown in the modern photograph is the only surviving original construction. In 2007, permission was given to sell off the old southern platform site in order to build an apartment block, which remains undeveloped in 2013. The inset shows a Flixton to Trafford Park and Stretford third-class railway ticket, issued before 1956.

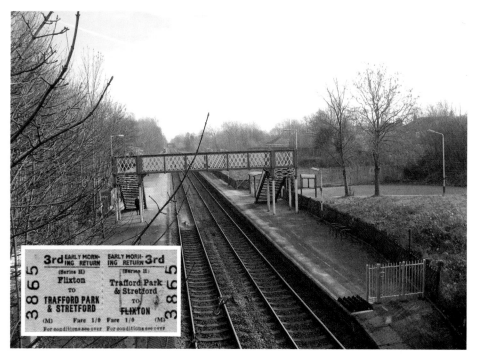

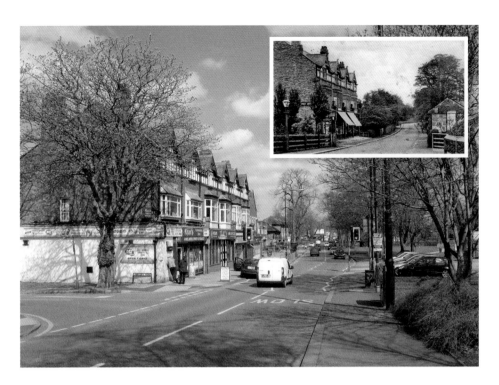

Station View and Millott's Tithe Barn, 1904, and Millott's Tithe Barn, Flixton, *c.* 1890
Station View, on the left, stood opposite Millott's Tithe Barn (*inset*), with the block expanded from four to six units by the 1920s. The 1911 *Slater's Directory* shows the post office standing next to Williams Deacon's Bank, Walton Brothers grocery store and Johnson's Confectioners, which was also the telephone public call office. The tithe barn was built around 1781, named after its owner in 1823, William Millott, and partially demolished around 1950. It had served as both village post office and shops.

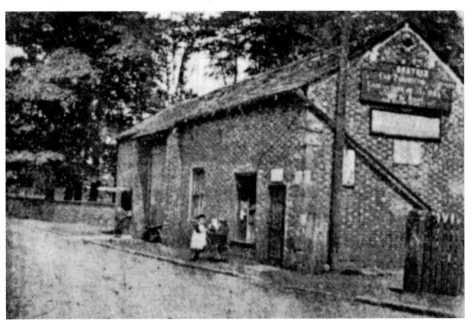

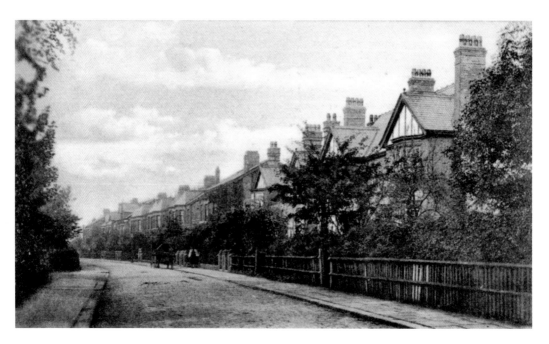

Western Road, *c.* 1900, and Footpath at Western Road, Flixton, *c.* 1890
Brook Farm, tenanted by the Walkden family, was located along Western Road at Gale's Brow, where it turns sharply towards Irlam Road. De Brook Farm and Broom Farm were also located close by. Western Road was originally named Bruce Road. In 1892, a ballot of residents renamed it Western Road, with Livingstone and Moffat offered as alternatives. Before development, Western Road was a footpath (*inset*), which was stopped up in 1934 due to the development of Rothiemay Road in 1933.

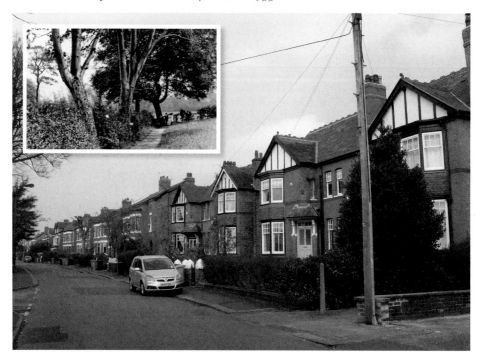

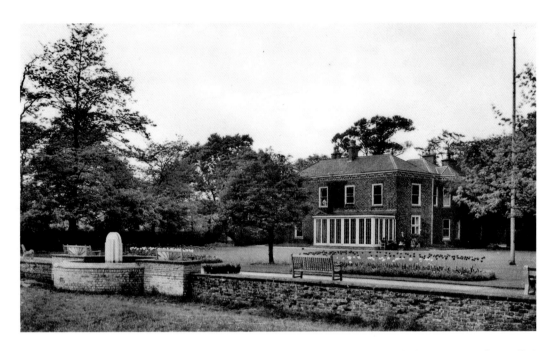

Flixton House and Grounds, Worthington-Wright Estate, *c.* 1950, and The Vinery at the Walled Garden, 1930

Built in 1806 by Justice Ralph Wright, whose monument is in St Michael's churchyard. The ballroom extension was carried out by the last squire, Samuel Worthington Wright, who died in 1934. The house and grounds were purchased by Urmston Council and opened to the public on 28 September 1935. Flixton House is now a Grade II listed building. The Wright family are most famous for their involvement in the closure of the Bottoms footpath and their failed attempts to stop up rights of way in 1827.

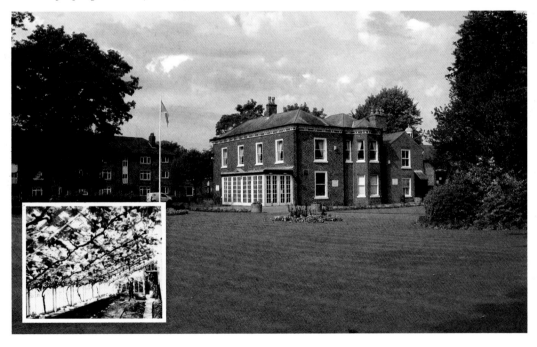

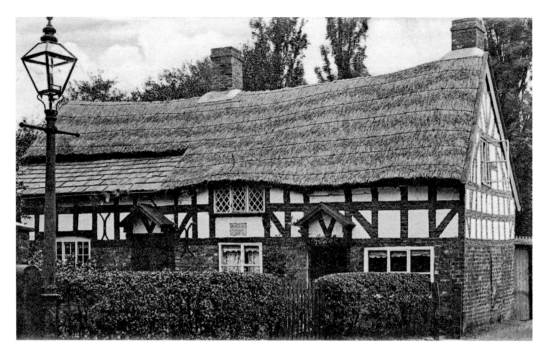

Hathaway Cottage and Shakespeare Cottage, Flixton Road, Flixton, 1903
Based very loosely on the style of the Hathaway and Shakespeare cottages in Stratford-upon-Avon, these were built in 1721. The cottages were demolished and replaced by the caretaker's house at the John Alker Hall, Flixton Road, in 1927. *Slater's Directory* for 1919 lists one of the cottages as Warwick and the other Hathaway, with the area surrounding them called Pears (Peers) Fold. The land behind the cottages, known as Smithy Field, is now the site of Whitegate Park.

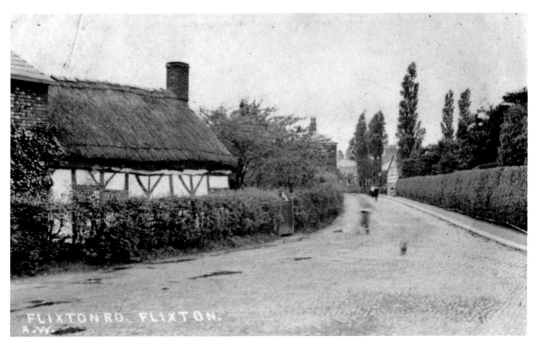

Junction Cottage, Junction of Flixton Road and Irlam Road, Flixton, 1906
Junction Cottage sat on the south side of Flixton Road, opposite Shakespeare Cottage, Hathaway Cottage and Holly House, and was tenanted by the Johnson family. It was half timbered and had a thatched roof. Behind Junction Cottage, the silhouette of Park House, located in front of Flixton House, can just be made out. The Coach House, now accepted as a part of Flixton House, is thought to have originally belonged to Park House. Today, of the named dwellings, only Flixton House survives.

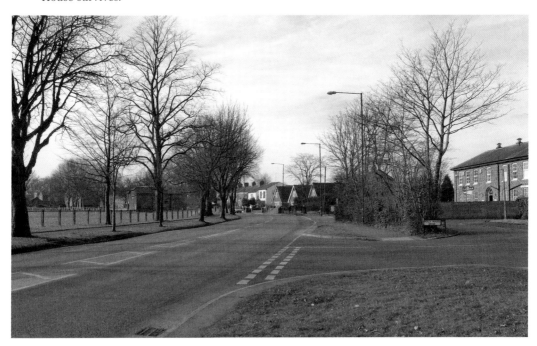

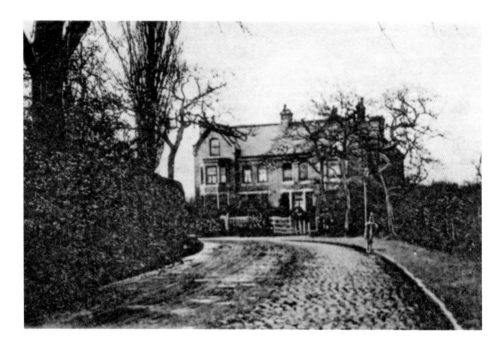

Irlam Road, *c.* 1900, and Marlborough Road, Flixton, 1907

This corner, known as Hollyhedge or Newton's Corner, looking towards Irlam Road's junction with Marlborough Road (*inset*), was noted for its well-trimmed holly hedge (on the left of the photograph), with some remnants surviving today. The residence here, Holly House, was once owned by Margaret Ellen Newton (1843–1912), who donated the clock faces to St Michael's church. In 1950, the land was purchased by the Diocese of the Catholic Church, with Holly House Drive taking its name from the original house later constructed on the site.

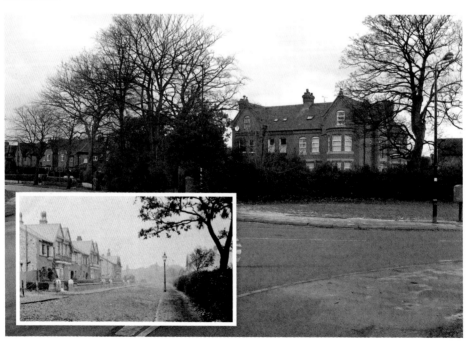

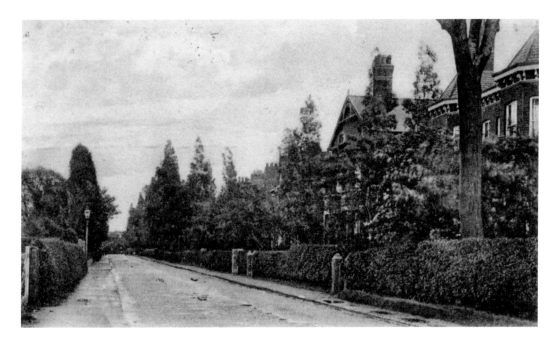

Irlam Road, Near Smithy Field, 1904, and Advertisement for Houses on Rothiemay Road and Cranford Gardens, Flixton, 1933

Suburban growth took place here around 1880–1940, with Rothiemay Road in 1933 (*inset*) as a typical example. The photograph looks towards the junction of Irlam Road and Flixton Road, where the smithy was located. Flixton Road was known as Cockedge Lane towards Urmston and Smithy Lane towards Flixton. Irlam Road was Miller's Lane to Brooklyn Avenue, where it became Green Lane to Towns Gate. The smithy and attached shop were demolished in 1953. Smithy Field was located behind the Victorian villas on the right.

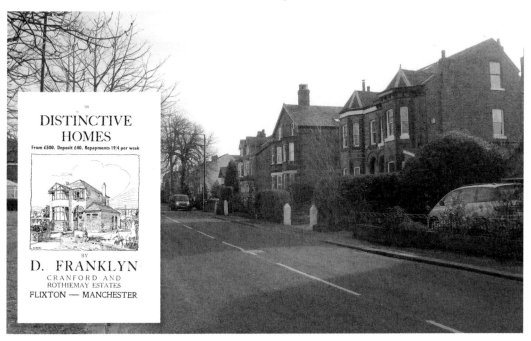

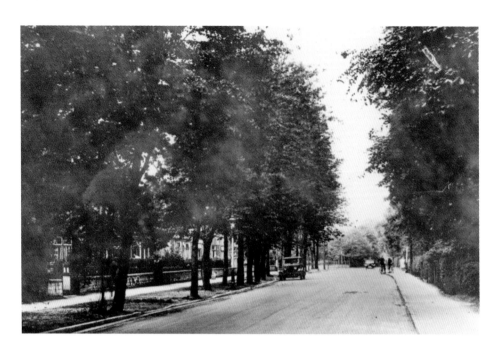

Irlam Road, 1920, and David Herbert Langton of Morningside, Flixton, *c.* 1890–1906
The Grange, built around 1893 by timber merchant James Ashton, stands to the right on Brooklyn Avenue. Morningside, the former home of local historian David Herbert Langton (*inset*), who wrote *A History of the Parish of Flixton* in 1898, is situated behind the photographer on the left. Langton lived here from around 1890–1906 when the family moved to Bramhall. Also on the left was Wibbersley House, now Wibbersley Park, formerly a Red Cross hospital for wounded soldiers (1914–19), demolished around 1924.

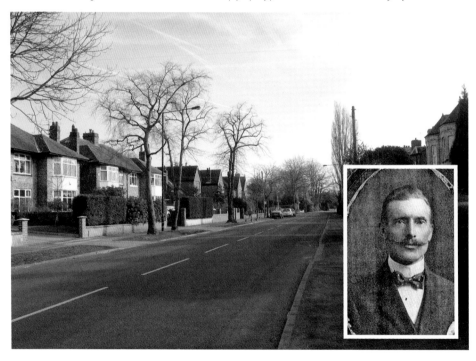

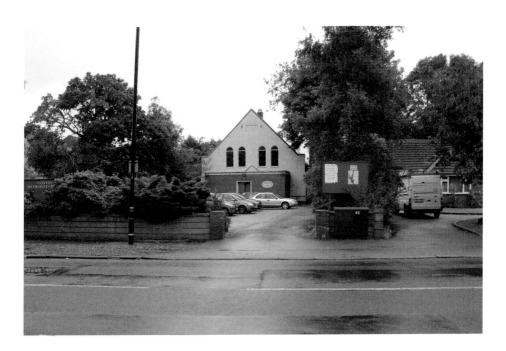

Flixton Methodist Church, 2009, and the Site of the Former Methodist Church, Irlam Road, Flixton, Autumn 2013

Flixton Methodist Mission was formed in Thomas Woodnett's cottage on Woodsend Road, which proved to be too small. The new church on Irlam Road replaced it in 1894, opposite Millford Avenue and near to the junction of Goldsworthy Road and Irlam Road. It was extended twice, in 1927 and 1956, and was demolished between February–April 2013 for a cul-de-sac and four houses. Originally a Wesleyan and Primitive Methodist chapel, its congregation has relocated to Hayeswater Road.

The Red Lion, St John's Former New Mission Church and Current Church of England Building, Junction of Irlam Road and Woodsend Road, 2009

Edward Booth was brewing at The Lion, located at Three Lane Ends, in 1782. Demolished in 1967 and replaced successively by two further structures, it was well known for its orchards, gardens and bowling green, which had a pavilion and refreshment bar. The green, according to Langton, was once used for bear-baiting. The Red Lion closed in 2009, was demolished in January 2011 and replaced by De Brook Lodge Nursing Home. St John's Mission is now a nursery. The inset shows nearby Brooklyn Avenue in 1930.

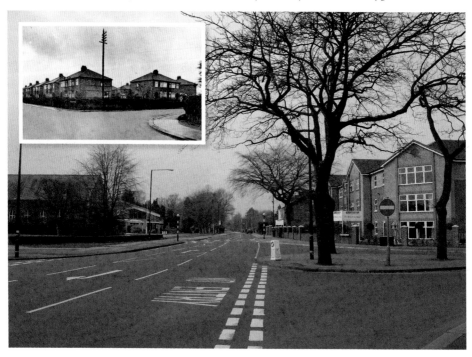

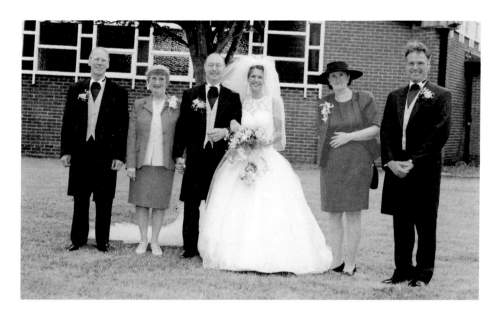

St Monica's Roman Catholic Church, Woodsend Road South, 11 July 1998, and St John's New Mission Church, Irlam Road, Flixton, 1930

The parish was founded in 1950, with the purchase of Holly House. Services were held at the John Alker Hall, until the congregation moved to their own church in 1953, later relocating to St Monica's church, built in 1969. The church has an attached school, with the infant school opening in 1959, the junior school in 1964 and a nursery unit in 1994. St John's Mission, next door to St Monica's, was founded in 1925 and the new church in 1968.

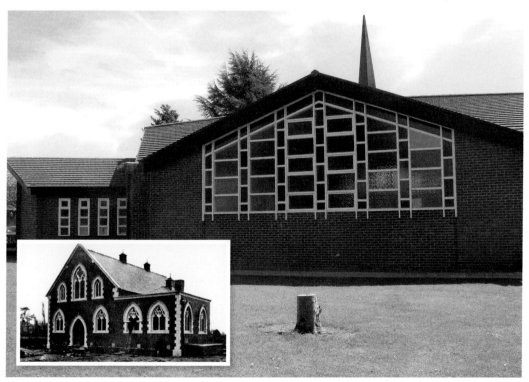

The Railway Tavern, Irlam Road, Flixton, 1920

First noted on the 1871 census, the 1843 Flixton Tithe Map records a 'beer shop' at this location, so there is a precedent for an establishment of this type here from an earlier date. Named after its view of the old Manchester to Liverpool railway and rebuilt around 1900, it was originally an old cottage, with evidence of development from the late eighteenth century. The adjacent Wellacre Junior School opened in 1953. Rowan Tree Cottage and John Henry Royle's Rocksavage Cottage are also neighbours.

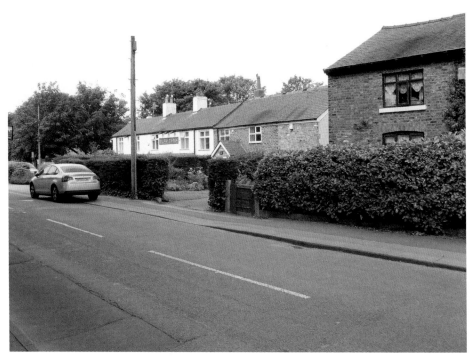

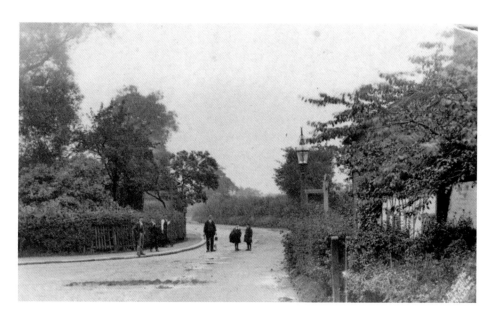

Boat Lane at Towngate Farm, 1923, and Irlam Locks, Flixton, c. 1950

Boat Lane, now Irlam Road, led west towards the Manchester Ship Canal and Irlam Ferry (1712–1975). The ferry transported Flixton workers employed at the Co-operative Soap & Candle Works and Steel Works, near Irlam Locks (*inset*). Towngate Farm, and later Town Gate Drive (1991), lay on this section of Boat Lane close to the ferry. Also located here were Boat Lane Farm on the north side of Boat Lane and Warburton Wall Farm, opposite Towngate Farm.

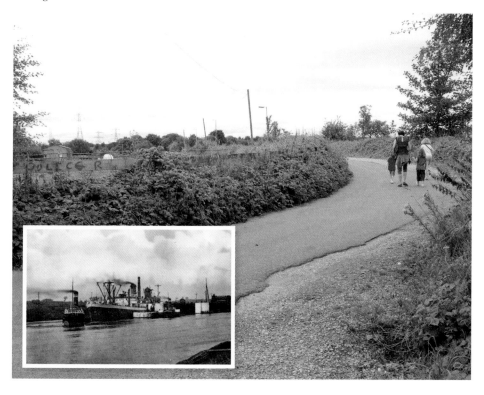

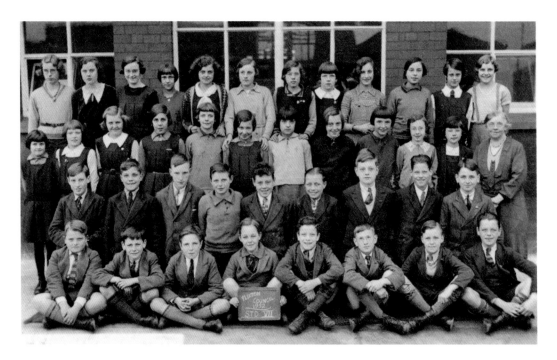

Flixton Council School, Standard VII, Delamere Road, Flixton, 1932
Delamere Road, established in 1897, is a no through road, with Flixton Council School, opened in 1911, located at the end of it. The school's central gable, consisting of three large windows, is the site of the 1932 class photograph. Located at Delamere Road's junction with Flixton Road, on its west side, Flixton Institute was used as a hospital in the First World War. On the east side of the junction is Flixton Manor Nursing Home, developed out of two former residences.

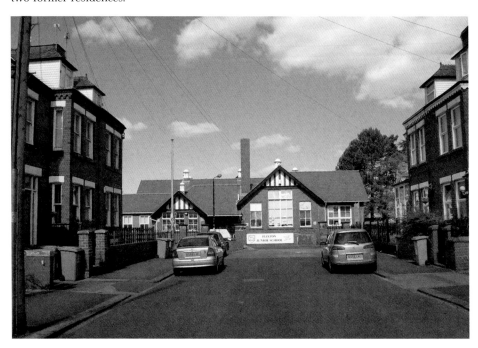

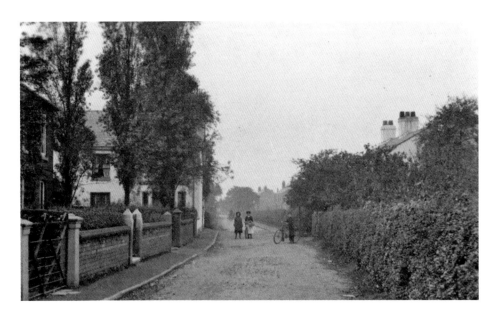

Flixton Poorhouse, Flash Lane, 1914, and Flixton Cricket Club Sports Day, *c.* 1930
The moorland that covered this area was reclaimed in 1844. In 1914, the poorhouse, known as Whitelake View, was at right-angles to Moorside Road, originally Flash Lane, in Flixton. These cottages were provided by Peter Warburton in 1769 and joined to form one almshouse. They were sold in 1861, reverting to residences by 1864 and being further divided by 1884. The buildings were demolished in 1956. Thorn Farm is opposite and Flixton Cricket Club on Moorside Road (*inset*), formed in 1891, is on the far left.

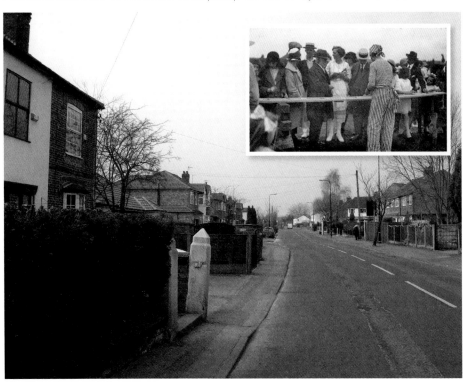

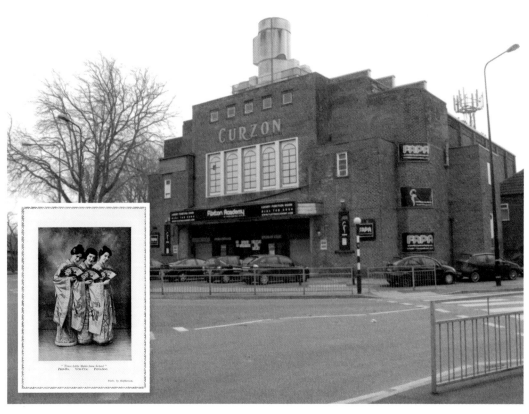

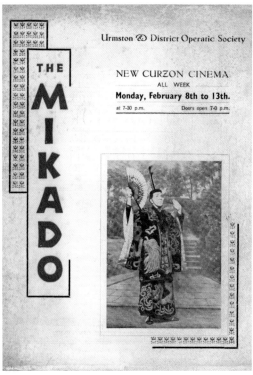

Production of *The Mikado*, New Curzon Cinema, Bowfell Circle, Flixton, 1937, and Three Little Maids From School

The cinema was built by Eaton Nash, once of Highfield House, Urmston. It is the only one of three former cinemas in the area whose building is still standing, as Flixton Academy of Performing Arts. Construction of the cinema began in 1935. It possessed a stage area 45 feet wide and 20 feet deep, with three dressing rooms for live performances, like *The Mikado*, performed by the Urmston and District Operatic Society (8–13 February 1937). The Curzon closed as a cinema in September 2008.

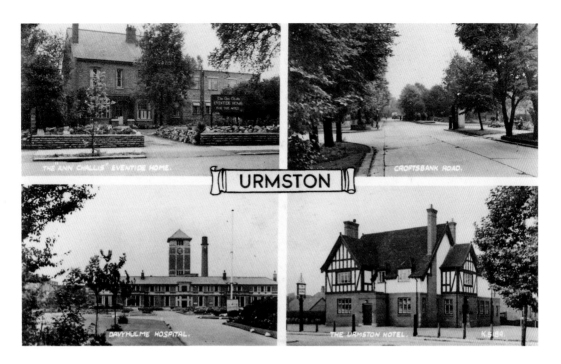

Views of Urmston, c. 1947

Above can be seen the Ann Challis Eventide Home, Crofts Bank Road, Davyhulme Hospital and the Urmston Hotel. The Meadows, built around 1880, became the Ann Challis Eventide Home for the Aged, and is now the Ann Challis Residential Home for Ladies. It was established in 1947. Ann Challis was the wife of Stretford Rotary Club's president. Like the original Manor Hey Hotel next door, the home was extended and modernised in order to perform its new role. The Urmston Hotel was built in 1938, and the newer section of Crofts Bank Road was briefly named Talbot Road.

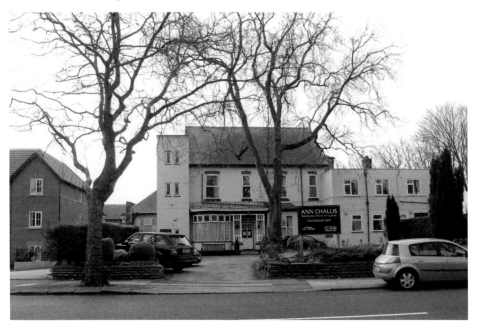

Old Cottage in Jack Lane, 1906, and Old Cottage in Ciss Lane, Urmston, 1906

During the early nineteenth century, the occupant of Jack Lane Cottage used to leave his front door open so schoolchildren could see the clock and not be late for school. Jack Lane and neighbouring Ciss Lane (*inset*), were redeveloped around 1935 but were not renamed, unlike nearby Chadwick (Lover's) Lane, called Bradfield Road in 1959. The last cottage was demolished around 1938 at Jack Lane's junction with Higher Road. At its junction with Stretford Road was the White Lion Inn and later Bailey's Mill, established in 1923 but now demolished.

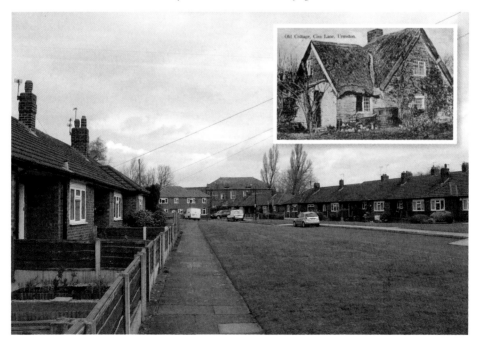

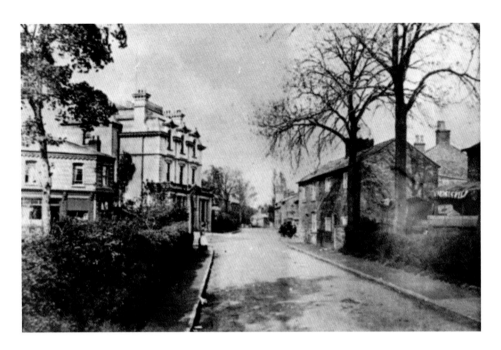

Lord Nelson Hotel, Stretford Road, 1886, and Horse Tram Terminus, Urmston, *c.* 1901
The hotel was built by members of the Royle family in 1805 to honour Lord Horatio Nelson's death at the Battle of Trafalgar, and was rebuilt in 1877. Colonel Ridehalgh, Lord of the Manor, held a court baron here for the Manor of Urmston twice a year until around 1890. Bear-baiting once took place on the courtyard in front of the hotel. Later, a bowling green offered more genteel entertainment. Beginning in June 1901, the hotel was a terminus for the horse bus (*inset*).

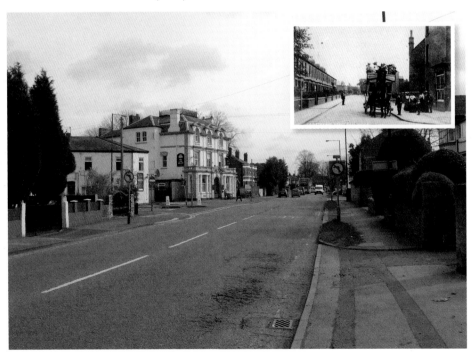

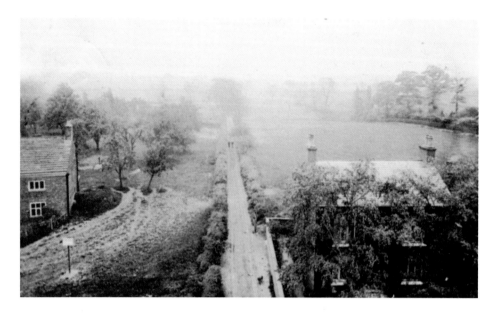

View of Urmston Meadows, and Meadow Road, Urmston, 1905

Trafalgar House (*above right*), built around 1820, stands directly opposite the Lord Nelson Hotel at the junction of Stretford Road and Meadow Road. Croft Farm, occupied by the Taylors, is to its left. Cob Kiln Lane was situated at the end of Meadow Road, where it is said there was once a rifle range. The lane led to Cob Kiln Woods, where there was a brick kiln giving the lane its name. Meadow Road only became known by this title some time after 1910.

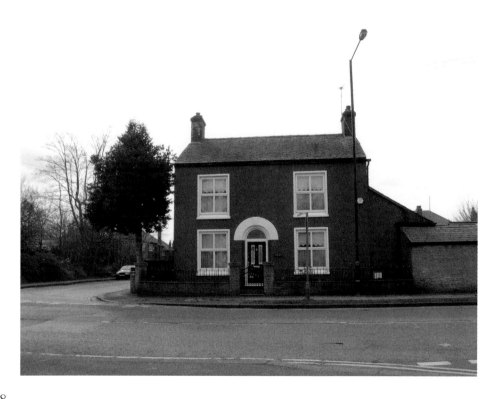

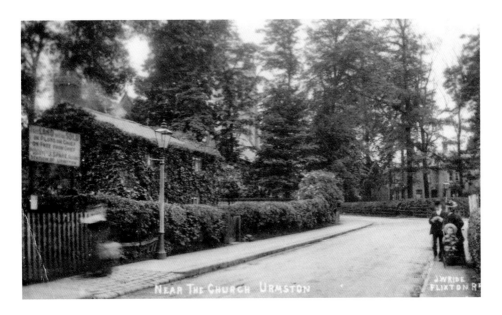

Stretford Road, 1920, and Stretford Road, Urmston, *c.* 1910

The cottage on the left, built around 1830, is now the location of St Clement's vicarage. Its neighbour was the residence of George Spark, a local builder; the sign of his family firm 'Joseph Spark' is shown. Sparks Builders constructed the 1920 semi-detached houses next to the vicarage, which are still there. Stretford Road underwent much suburban growth, from a country lane and haunt of the 'Gamershaw Boggart' around 1910 (*inset*), to the place where the M60 motorway bridge crosses today.

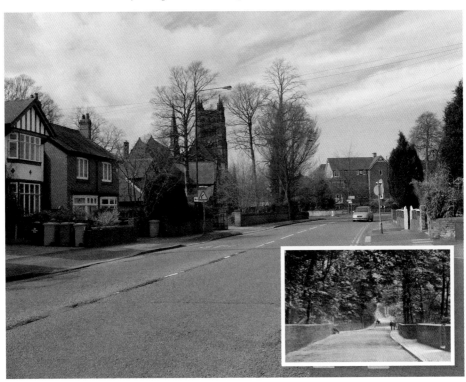

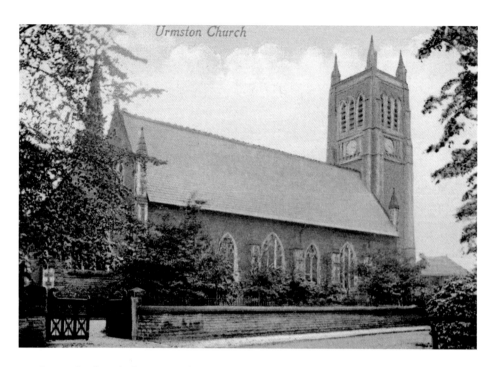

Urmston Church

St Clement's Church, from Stretford Road, Urmston, 1910

The church was founded in 1867 on land donated by Colonel Ridehalgh, and restored in 1874/75 and 1888. It was designed by James Medland Taylor and built by Mark Foggett at a cost of £2,125. The Rector of Flixton, Revd Charles Barton, named the church. The foundation stone was laid on 16 March 1867, the church was consecrated in January 1868 and became Grade II listed in 1987. In 1894, the organ chamber was donated by the Sparrow family of Urmston Lodge.

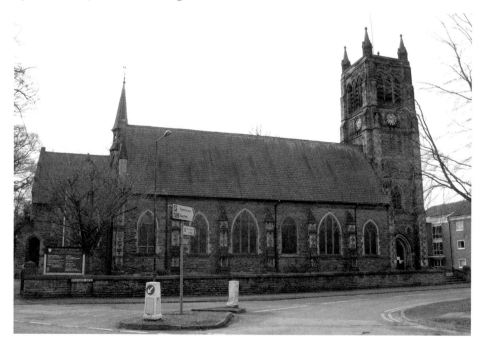

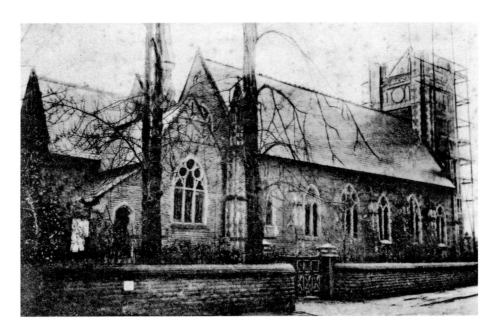

St Clement's Church Tower, 1903, a View from the Church Tower, 2013

The church tower was erected in 1903. The clock was donated by the Reade family, of Manor House, with one bell presented by Thomas Royle, both installed 1906, and a ring of bells installed in 1920. The 2013 view shows the new Eden Square Shopping Centre as the white complex in the middle and the green dome, far right, is the Trafford Centre. The rectangular building to its left is the Chill Factor. The left foreground shows the old police station, built 1904. The inset shows St Clement's church without its tower in 1874.

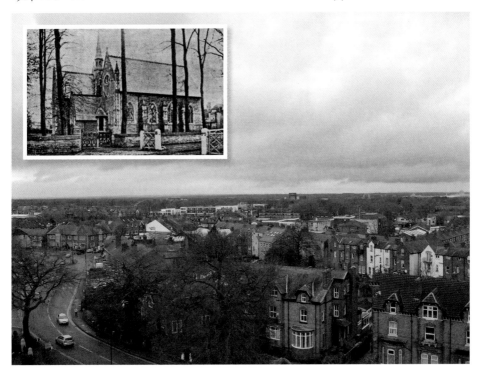

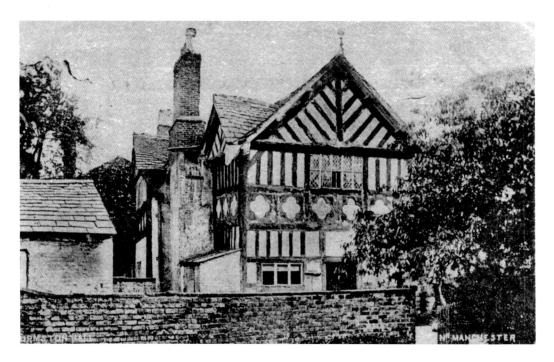

Urmston Old Hall, Manor Avenue, Urmston, 1905
Built in 1580 and demolished in 1937 despite efforts to save it, Urmston Old Hall was a gabled, timber and plaster Tudor building, decorated with lozenges and trefoils. Its side elevations were brick, and a date of 1731 on the north side suggests later renovations, with the initials 'IHE'. Mentioned in William Hyde's will of 23 August 1587 and later owned by the Egertons, by 1901 it was a farmhouse belonging to the Ridehalgh family and tenanted by Jonathan Stott.

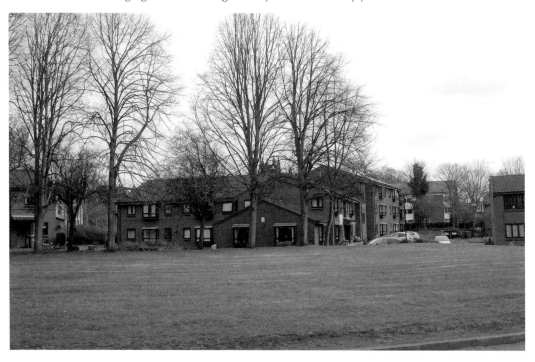

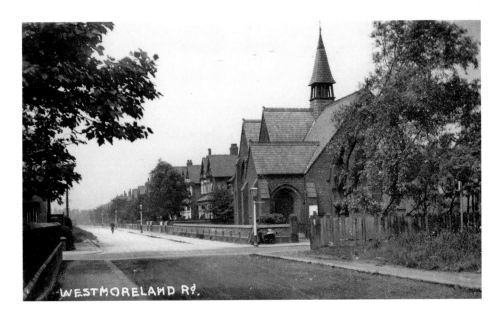

Unitarian Church, Junction of Westmoreland Road and Queens Road, *c.* 1910, as seen from Penwood, Later Manor Garden, Stretford Road, *c.* 1945

The earliest record of a Unitarian service in Urmston dates back to 1894, with the church in use today built in 1899. It officially opened in 1901 with an opening sermon delivered by the Revd C. Hargrove. Today, the church is called Queens Road Unitarian and Free Christian church. Nonconformity remained popular in Urmston. From 1813, Methodist meetings were held in the house of Butcher Booth. Later, in 1872, a Methodist church was built on George Street and replaced in 1905.

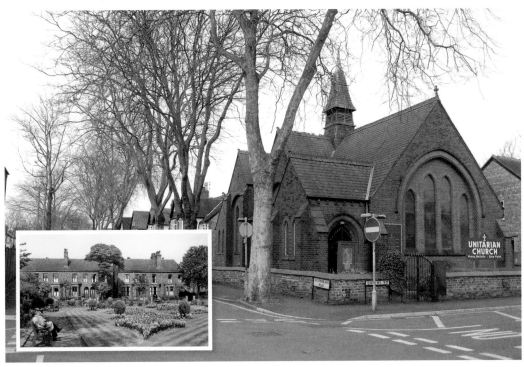

The Meadows, Urmston, 1903

The photograph of 1903 shows the bridge crossing 'Old Eea Brook,' with St Clement's church in the background. 'Urmston Eeas' was the original name for Urmston Meadows. The many footpaths and rights of way that once proliferated here have, in many cases, been partially stopped up and are now part of an equestrian centre. Trees on this land now obstruct a view of St Clement's church, with the modern photograph taken from the footpath next to Urmston Cemetery, opened in 1893.

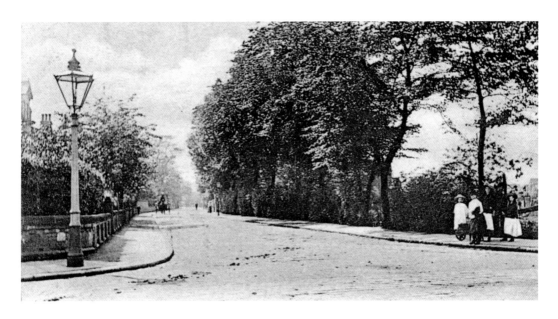

Church Road, Urmston, Looking Towards Flixton, 1903, and Moss Grove, Urmston, *c.* 1920
Church Road was previously known as Church Lane or Shaw Hall Lane. This photograph is looking from the corner of Grange Road towards Moss Grove (*inset*) on the right, renamed Dartford Road from around 1926. Here is thought to be the site of Tim Bobbin's cottage, now long demolished. Born in Urmston on 16 December 1708, the satirist and poet was baptised John Collier at Flixton on 6 January 1709. Church Road has been widened and received utilities from 1881. It was also widened in stages from 1950 to 1969.

Church Road, 1929, and Church Road, Urmston, Looking Towards Chassen Road, Flixton, *c.* 1960
The terrace on the left still stands today, as does the pillar box on the right, although it has been moved from the edge of the pavement for safety reasons. Church Road around 1960 (*inset*) shows that the roadway was narrower and that there were more trees than today. The shop at the end of the terrace, next to the delivery van, was Kenny and Hollis Ladies Fashion, with Rushton's Shoe Repairs in the middle and Duckworth's Grocers nearest the photographer.

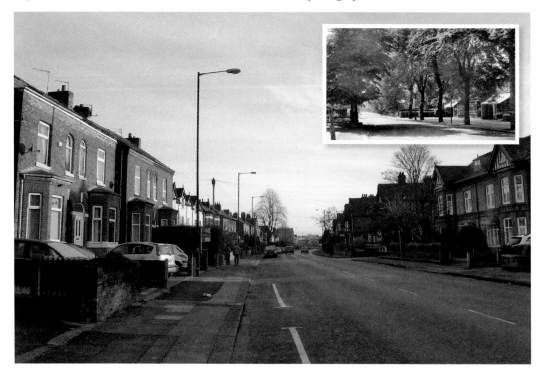

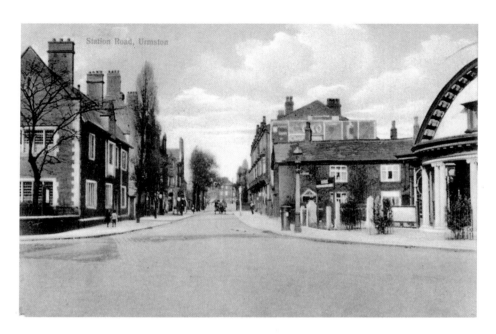

Station Road, Urmston

The Temperance Hall, Station Road, 1914, and Church Road, Urmston, c. 1950
Built in 1909 and originally a Temperance Billiard Hall, it provided entertainment without the temptation of alcohol. After the Second World War, it had a short spell as a roller skating rink, until it was taken over by Vernons and became a supermarket. It came up for sale in 1956 and was occupied by Terry's Store. In recent years, it became a restaurant, but now has a 'for sale' sign in situ. It is opposite the old police station, now commercially developed. The inset shows Tallon's newsagent's and the Co-op, opposite Barnfield, around 1950.

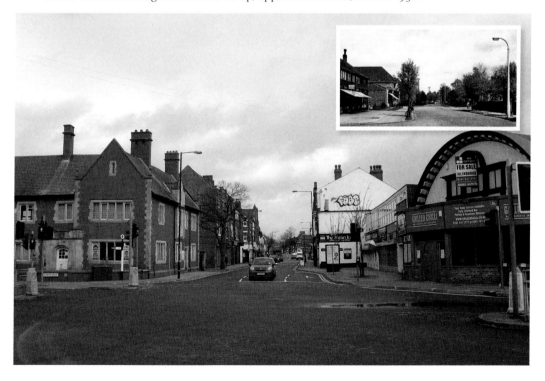

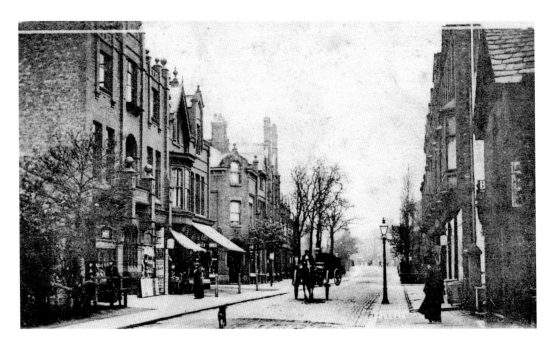

Gladstone House, Station Road, Urmston, 1903

The first Liberal political connection to Urmston began in 1883, when a club was opened by William Agnew MP at Lyme Grove. Their headquarters at Gladstone House, on the left of the 1903 photograph, were proposed in 1883, built on Station Road in 1891, and opened in September 1892. Gladstone House was vacated in 2006 for offices on Primrose Avenue, and is now retail premises. Further along Station Road was a Woolworths store (around 1928–2009, *inset*), and a post office (1890–1902).

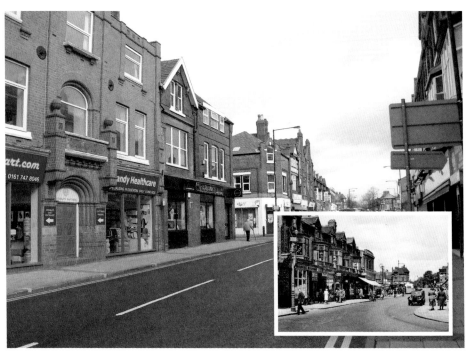

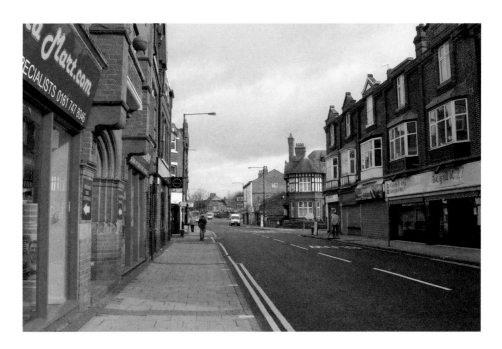

Station Road, Looking Towards Gloucester House and the Victoria Hotel, Urmston, 1914
Gloucester House, in the centre of the 1914 photograph, was built in 1880 by the Mayne family. It was used as a doctor's surgery, which it remains today. Doctor Walter F. Mayne practiced in Urmston for nearly fifty years, leaving the area in 1927. Further along Station Road, beyond Gloucester House, stood the Victoria Hotel, built around 1872, replacing the Duke of York, which was demolished to build Urmston station. It was superseded in 1965/66 by a new public house on Victoria Parade.

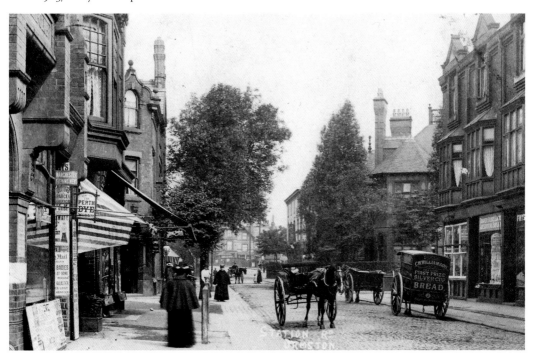

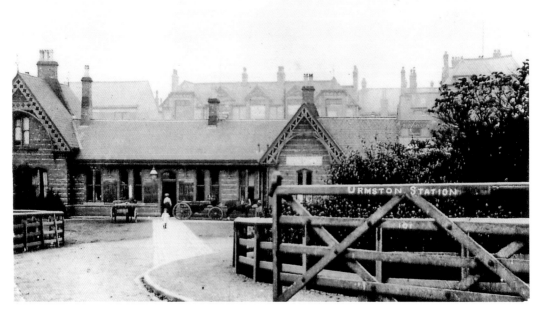

Urmston Railway Station, *c.* 1900, and the Former Station Building, 2013
Opened on 2 September 1873, the original station buildings were Gothic in style. In 1889, a new booking office was constructed on the Railway Road side of the bridge, and a ladies' waiting room erected. The station footbridge was demolished in 1927 when the road bridge was widened, and the platform canopies were removed in 1965. It was also the terminus for North Western Buses' Manchester route, beginning in 1928. The station building reopened in 2008 as a restaurant and public house.

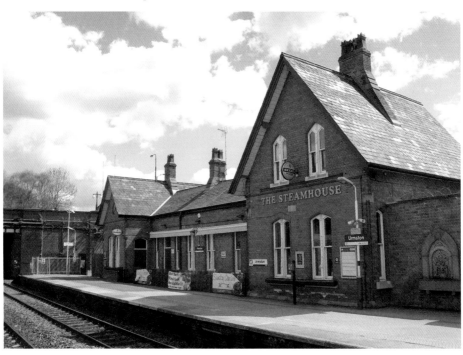

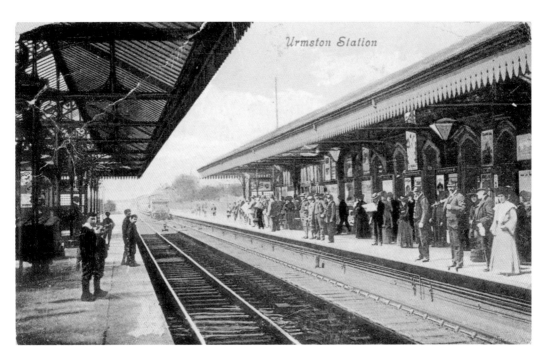

Urmston Railway Station Platform, Looking Towards Flixton, *c.* 1910
The line here was originally named the Cheshire Lines Railway. The Duke of York public house was demolished for the station site. The platform canopies, shown in the photograph of around 1910, were constructed in 1889, with the waiting rooms and booking office (also shown) demolished and replaced with new buildings around 1990. The coal yards and sidings, once occupied by coal merchants, a cab hire company and a building merchant, have also been removed, to be replaced by modern housing and car parking facilities.

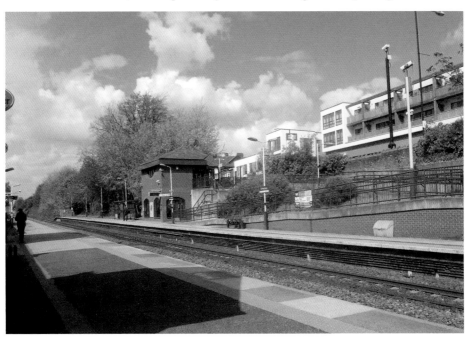

51

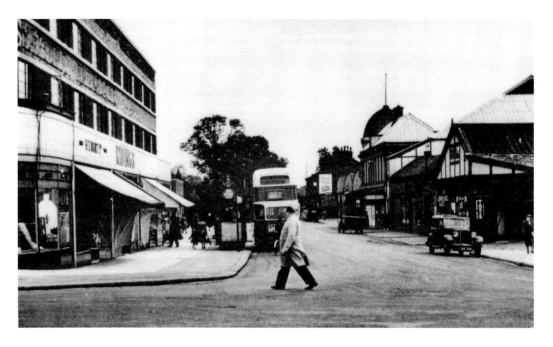

Higher Road and the Empress Cinema, Urmston, c. 1940

Originally the Urmston Rink (1910/11), it became the Empress Rink & Cinema around 1919 and the Empress Cinema in 1921. Built to accommodate 900 people, it was redesigned in 1934/35, increasing its capacity to 1,200. It closed on 11 October 1958 and was demolished in 1962. Victoria Parade was constructed on the site. Ridings carpet and furniture store dates from the 1940s. Higher Road, formerly Back Urmston, is the site of a Jewish cemetery, an Independent chapel (demolished 1912) and St Clements church school, opened on 4 February 1889 and demolished in 1996.

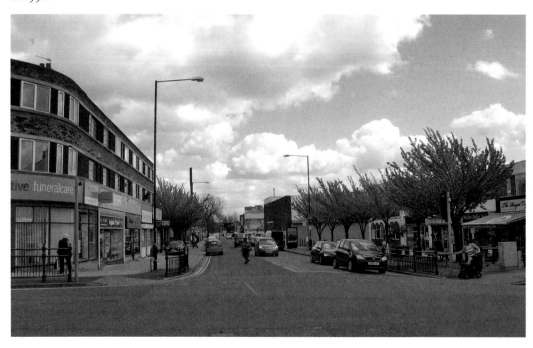

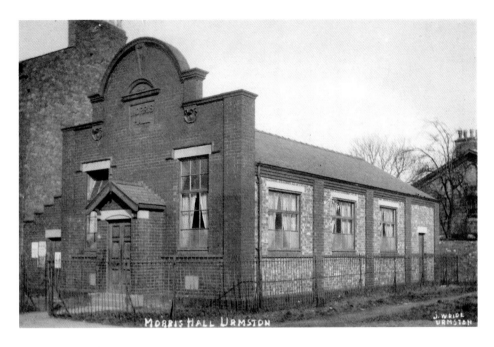

Morris Hall, Atkinson Road, Urmston, c. 1915

Morris Hall was opened on 1 July 1911, with the opening ceremony being carried out by Keir Hardie (1856–1915). He was the first Independent Labour MP and regarded as one of the primary founders of the Labour movement. The hall was named after William Morris (1834–96), who was the greatest British representative of Libertarian Socialism. It was once known as the Morris Lecture Theatre, and today is the headquarters of the Labour Party for Stretford and Urmston.

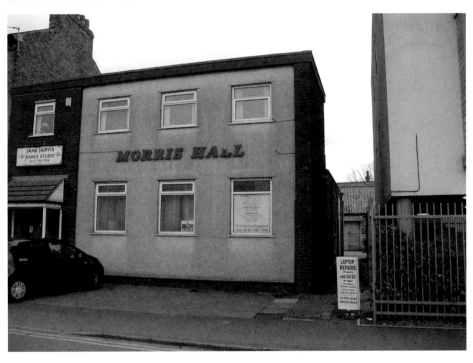

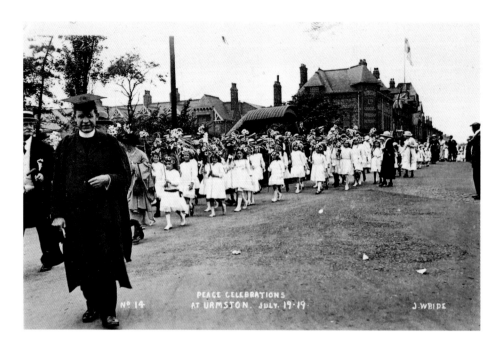

The Victory Parade, Station Road Bridge, 19 July 1919, and Crofts Bank Road from Station Road Bridge, Urmston, 1921

The Victory Parade was held to mark the end of the First World War, with a war memorial later erected in a section of Golden Hill Park, next to the modern police station. This was unveiled to the public in May 1927, and was paid for by the citizens of Urmston. It also commemorates those who fell in the Second World War. The parade is crossing Station Road Bridge, widened and reconstructed in 1927. The buildings behind the parade (*inset*) remain recognisable today.

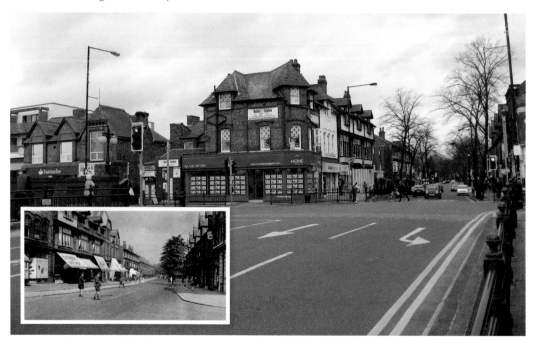

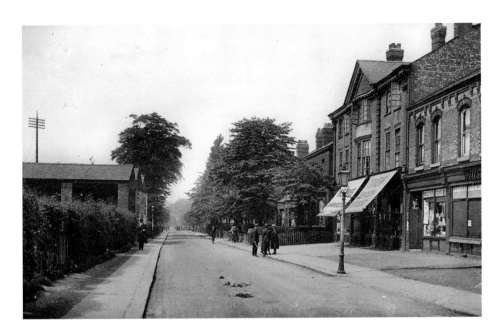

Flixton Road, 1922, and Flixton Road, Urmston, 1910
In 1922, the left side of Flixton Road was occupied by Moss Farm, with Henry Sutton as the farmer. Farmland, starting opposite Roseneath Road and ending near Urmston station, belonged to the smallholding, although most of Moss Farm was lost to the railway. Remaining farmland was developed for retail use in the late 1930s. On the right at Roseneath Road junction is English Martyrs Roman Catholic church, the current building dating from 1914. The school (*inset*), built in 1901, was replaced in 1935.

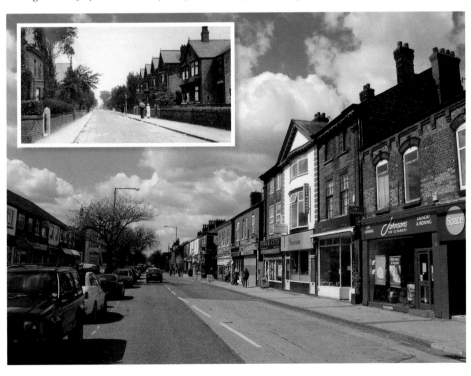

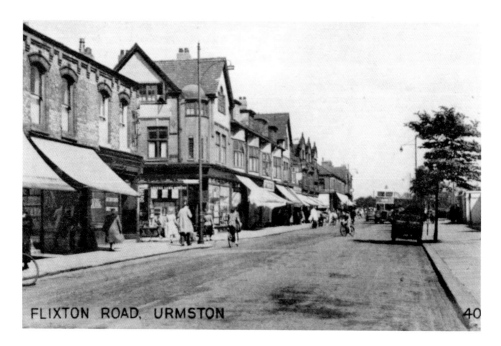

FLIXTON ROAD, URMSTON 40

Flixton Road, Looking Towards Urmston, *c.* **1940, and Looking Towards Flixton, 1921**
The left foreground shows Flixton Road's junction with Park Road (South). The buildings here remain intact today. Further along is the former junction with Winifred Road, now the white building, forming Eden Square, where a library, Conservative Party headquarters and car parking complete the facilities. Directly opposite Eden Square and Urmston station is the clock that once stood at the entrance to the old shopping centre. In 1881, my relative, William Hallsworth, ran his pawnbrokers business from No. 9 Flixton Road.

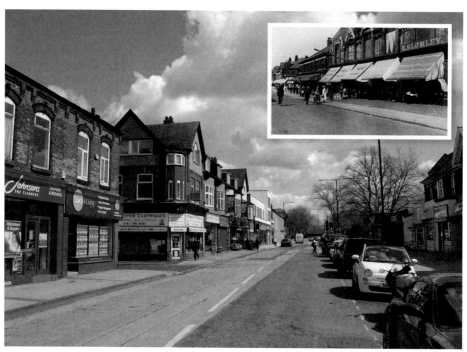

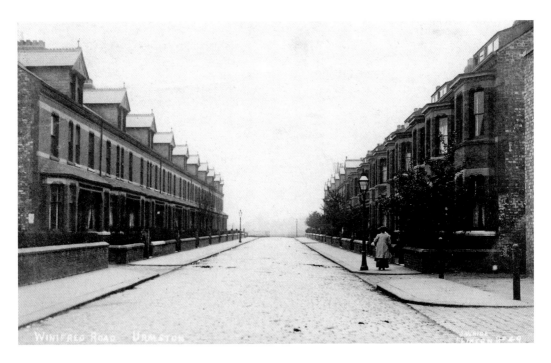

Winifred Road, Urmston, 1905

Winifred Road was originally the location of cottages in 1848 and is now the site of Eden Square. The road and buildings were lost to the first shopping centre, constructed in 1964/65. Urmston Corporation tennis courts were once here, as was the call office for the telephone service in 1911. James Wride, stationer, newsagent, hairdresser and local photographer, was at No. 8 Flixton Road in *Slater's Directory* of 1903, with a Co-operative store, opened June 1901, at Winifred Road's junction with Flixton Road.

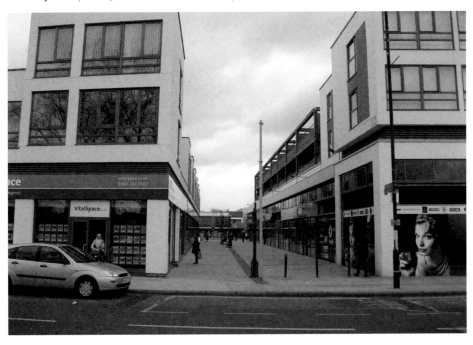

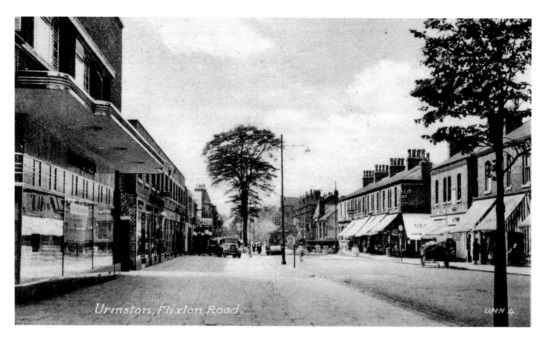

The Gas Showrooms, Flixton Road, Urmston, Looking Towards Flixton, *c.* 1940
The Gas Showrooms date from the late 1930s and were constructed on the fields of Moss Farm. The company known as Whitegates, trading as the Britannia Restaurant, later occupied the building, with the Gas Showrooms moving to premises on Station Road Bridge. The building is currently utilised as a bar and nightclub. The style of the property is still recognisable as classic 1930s Art Deco. Its most striking feature is the canopy, retained by the bar to great effect.

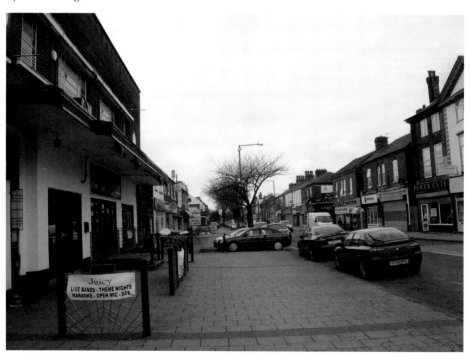

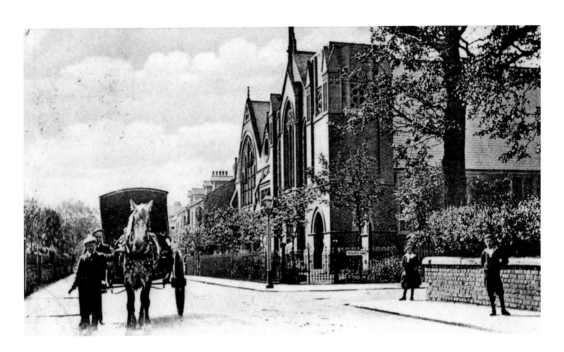

Congregational Church, Junction of Wycliffe Road and Flixton Road, Urmston, 1908
Services were first held on Roseneath Road around 1840. The church was constructed in 1879 and enlarged in 1901. Built by Waddington & Son of Manchester in Gothic Revival style, it was demolished due to dry rot in 1979. The congregation joined the Baptists at Greenfield Avenue, built in 1903. The church was never finished to the original plans, a fact alluded to in the featured postcard, with the writer commenting, 'You will notice it has not growd a spire yet.'

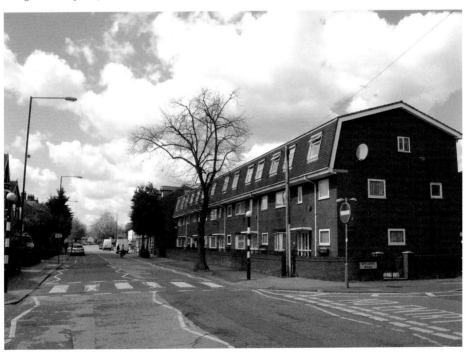

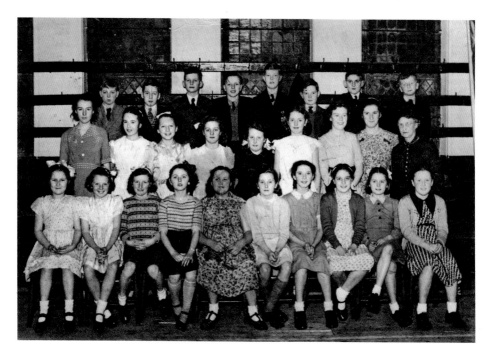

Urmston Council School Piano Recitals, Hereford Grove, Urmston, 28 December 1949
Originally Urmston Higher Grade School, opened on 9 January 1882, Urmston Council School was located on the north side of Hereford Grove, and is now Urmston Infant & Junior School. The photograph of Urmston Council School Piano Recitals in 1949 shows my mother, then Barbara Cliffe, third from the left on the front row. The photographer was J. H. Fraser of No. 7 Winifred Road. Names she recalls from her schooldays include her teacher Mr Chapman, Margaret West, Barry Burgess and Sheila Cross.

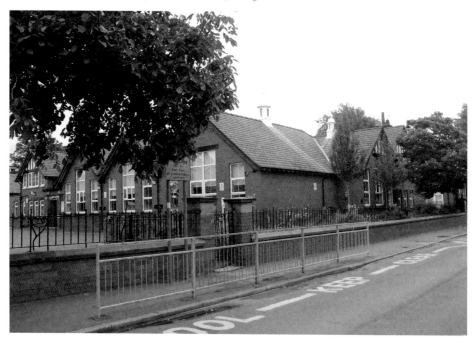

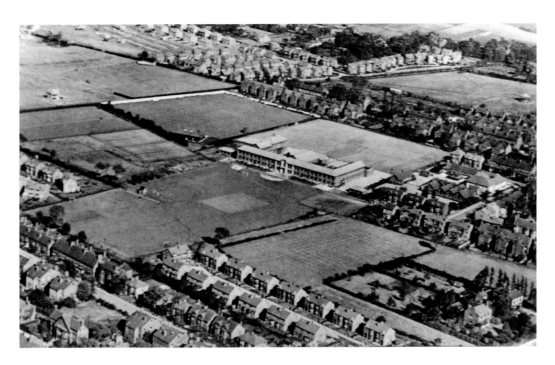

Aerial View of Urmston Grammar School for Girls, Newton Road, Urmston, 1929
Moorside Road East runs along the top of the photograph, ending abruptly and awaiting future development at the entrance to Urmston Cricket Club, which was established in 1846. In the centre is the grammar school, established in 1882, extended in 1888 and rebuilt in 1929. Above these can be seen Golden Hill Park and its bandstand. Today, Moorside Road East continues to Bowfell Circle at the Curzon, and the grammar school has an extension, built around 1991, as shown in the modern image, at right angles to the original school.

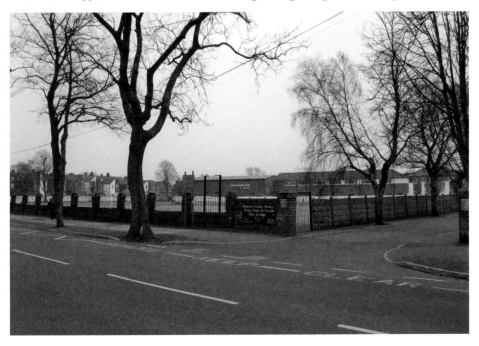

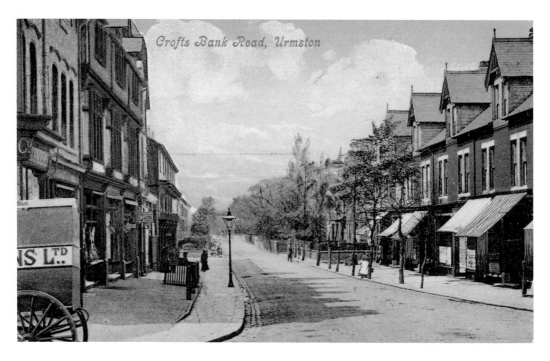

Crofts Bank Road, 1905, and Alliston, Crofts Bank Road, Urmston, 1914

On the left was Cuthbert's Butcher's, which retailed here from 1903 to 2005, and then became part of the NatWest Bank. Further along on this side was Silcock's Greengrocer's, previously The Creamery, which retailed here from 1929 to 1999, was later a florist's and is now a furniture store. On the right, at Crofts Bank Road's junction with Primrose Avenue, is Alliston Surgery (*inset*), formerly the practice of Doctors Graham and Wolstenholme. The terrace opposite became the old council offices (around 1964/65), then Eden Square.

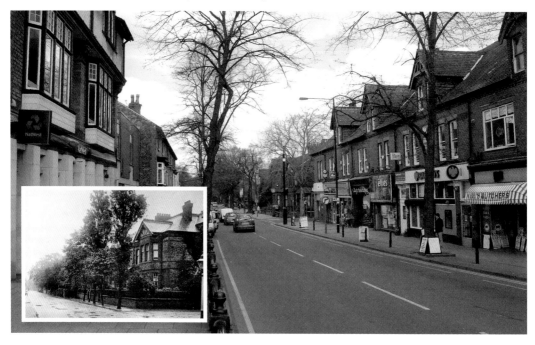

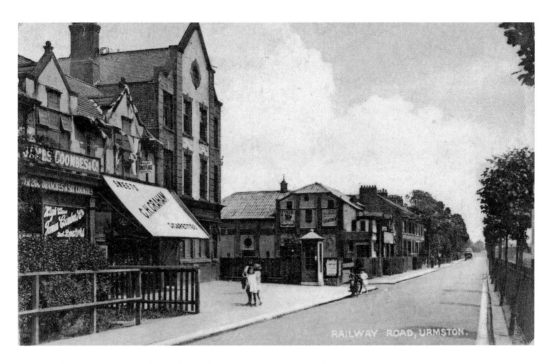

Railway Road and the Palace Cinema, Urmston, 1936

The terrace on the left was variously occupied by the Gardeners Institute and Allotment Society, *The Telegraph*, telephone exchange and shoemakers. Shown in the photograph, next to the confectioners, is the post office and beyond Urmston Market is the town's first purpose-built cinema, Urmston Picture Palace, which opened in 1912 and closed in June 1957. After Urmston Council tried and failed to buy it for use as an amateur dramatic theatre, it became a factory, eventually being demolished for flats.

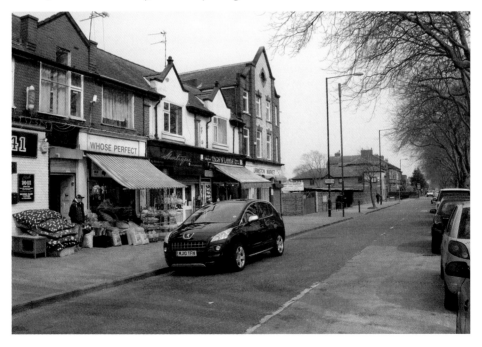

Railway Road and Westbourne Park, 1912, and Westbourne Park Gates, Urmston, 1905
Urmston Rifle Club was established here in 1889, with a miniature rifle range bordering
Oak Grove. It was said to be the first 'small bore' rifle club in the country. At its entrance
stood a gateway, sided by two towers (*inset*), on the left of the 1912 photograph. These were
removed in 1950, although the club still operated into the 1960s. Much of its land is now
allotments. Colonel Cody ('Buffalo Bill') became a patron of the club in 1903.

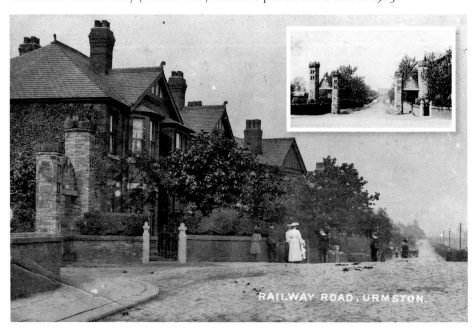

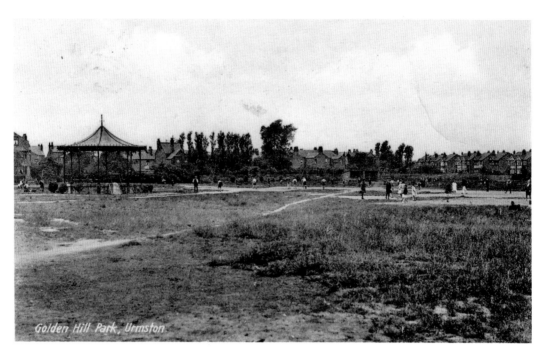

Golden Hill Park, Urmston, *c.* 1935

The park borders onto Crofts Bank Road, Moorside Road East and the war memorial. The park is much reduced in size, but once contained a bandstand, a pavilion, a putting green and tennis courts. There is now only a bowling green here, relocated in the early 1990s, and much of the original 10 acres is a car park. The park was eventually established in 1928, after initial resistance from local residents beginning in 1902. The site was originally a field named Golden Hill.

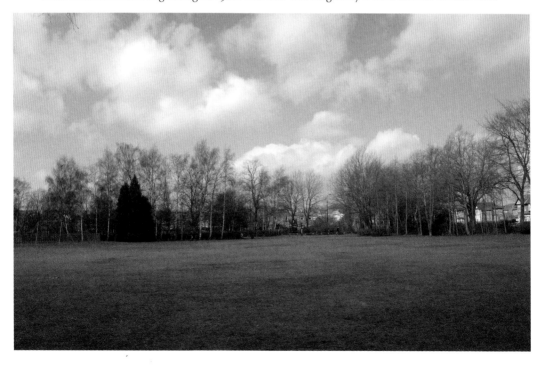

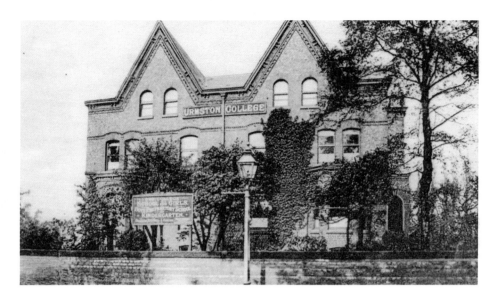

Urmston College, Crofts Bank Road, *c.* 1900, Council Offices at 'Arrandale', and War Memorial at Golden Hill Park, Crofts Bank Road, Urmston, *c.* 1930

Urmston College was established around 1898 as a high school for girls and preparatory school for boys in two houses, Roseleigh-Thorndale and Holmsdale, which later became council offices. It is not to be confused with Caius House School (Abbotsford) on Church Road. The site is now occupied by Arrandale Court. According to *Slater's Directory* of 1903, Arrandale (*inset*) was home to James Plowman, on the opposite side of Crofts Bank Road, nearer Urmston and next to Moorfield House. Both were used by the council until 1967 and the 1990s respectively.

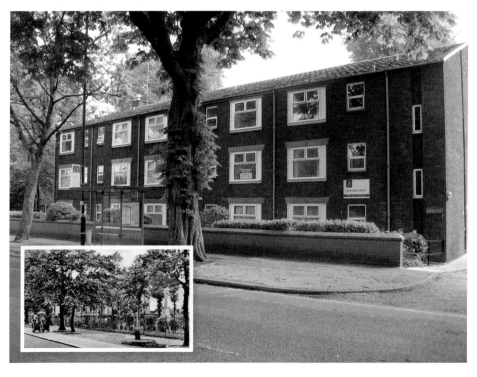

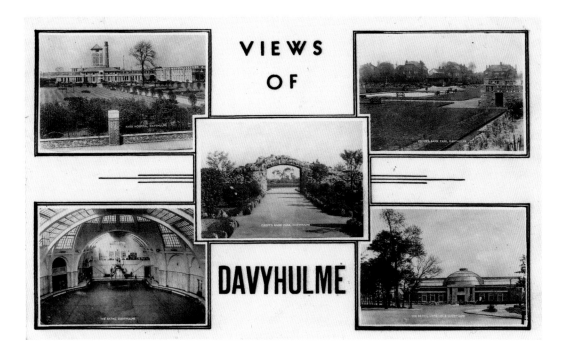

Views of Davyhulme, 1937

The images above show Park Hospital, Crofts Bank Park and the Baths. The first public baths were near the Bird i' th' Hand public house, built by the Stott family and demolished around 1900. The new baths, now Charleston Square, were officially opened by Cllr Lt-Gen. Samuel Stott on 31 March 1933. Built by Brew Brothers of Cadishead, with steelwork supplied by Edward Wood & Co. of Manchester, the dome reached 50 feet above the pool, which could be covered, mainly for boxing and dances. The Baths closed on 28 June 1987, reopening on Bowfell Road.

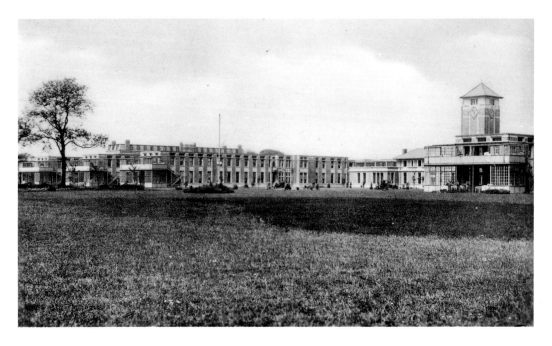

Davyhulme Park Hospital, Moorside Road, Davyhulme, 1930

In 1923, 30 acres of land were purchased for the hospital's construction. It was designed by Elcock & Sutcliffe and built by Gerard & Sons of Swinton. Two foundation stones were laid by the Earl of Derby and Sir Thomas Robinson MP on 2 July 1926. Admitting patients from 1928, it was officially opened by HRH Princess Mary, Viscountess Lascelles, in 1929. During the Second World War, Park Hospital became the US 10th Military Hospital, with the Glenn Miller Orchestra visiting in 1944.

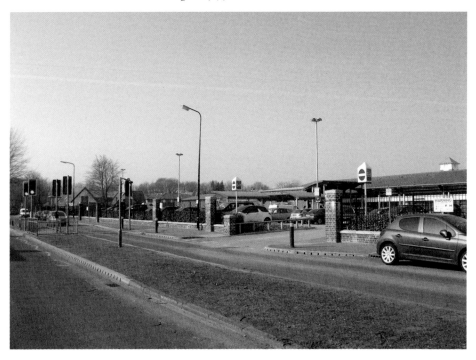

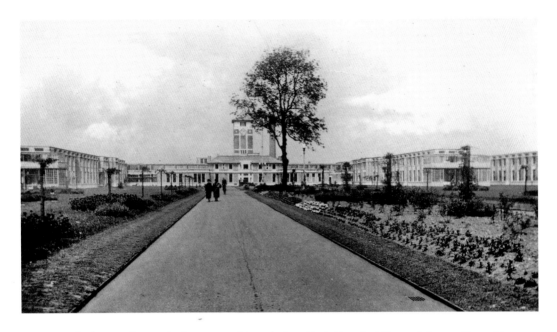

Davyhulme Park Hospital, 1930, and Davyhulme Park Hospital Nurses' Home, Moorside Road, Davyhulme, 1930

The hospital was returned to Lancashire County Council in 1945, reopening in 1946. On 5 July 1948, it was visited by Minister of Health Aneurin Bevan, who received the hospital's keys on the opening day of service, an honour for the first NHS hospital. Facilities included a nurses' home (*inset*), training school and open verandas on each ward for fresh air and light. Renamed Trafford General Hospital in 1987, it lost its maternity unit in 2010, and its A&E unit was controversially downgraded in 2013.

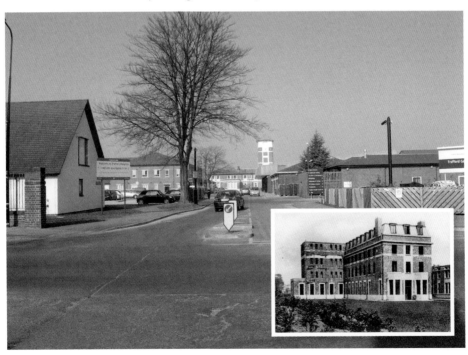

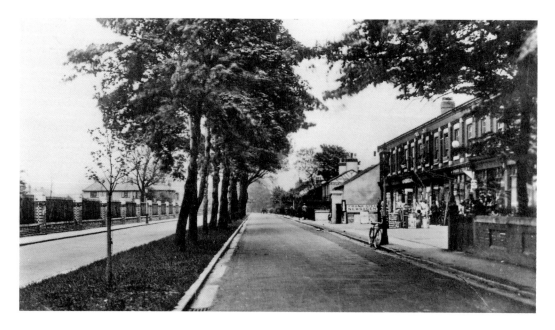

Moorside Road, Davyhulme, Looking Towards Davyhulme Park Hospital, *c.* 1930
Moorside Road originally followed the course of Cornhill Road and continued towards
Flixton via Bowfell Circle. Moorside Road East, from the circle to Crofts Bank Road, along
Carr's Ditch, was completed in 1937. Beyond the Garrick's Head public house, rebuilt
around 1928, it was known as Flash Lane, after Flash Farm, and is the boundary between
Flixton, Urmston and Davyhulme. Wesley Cottage, home of James Bent, a weaver, and the
first Sunday School in 1785, is the second building after the terrace.

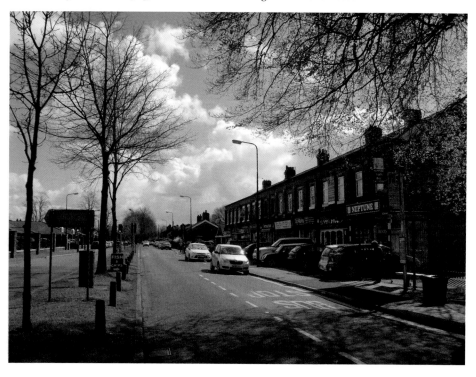

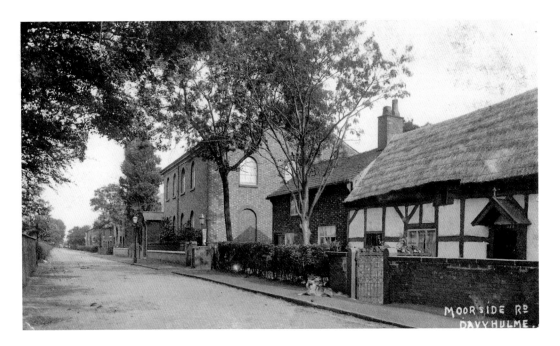

Moorside Road, 1905, and Date Stone from the Chapel Extension, 1805, Now at Flixton
Wood's Farm, built in 1666 and demolished in 1913, housed Wesleyan clergy from the adjoining chapel. The cottage was originally owned by John Wood and descendants into the nineteenth century. An inscription on the cottage read 'W. W. 1666'. The Wesleyan chapel was opened by John Wesley in 1779, extended in 1805, and replaced by Brook Road chapel in 1905, the land being donated by John Wood's great-great-grandson. The date stone (*inset*) is from Moorside Road. Nearby, The Fold is located where the Wesleyan Methodist school, opened in 1846, once stood.

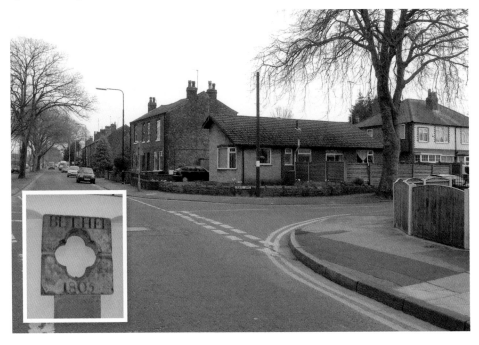

Davyhulme Hall and Park, Davyhulme Road, *c.* 1880, and Davyhulme Hall Farm, *c.* 1920
Davyhulme Park was the seat of the Hulme family from 1154 and has successively been a
farm, racecourse and golf links. It was sold to William Allen in 1765, who went bankrupt
in 1789. The Norreys family were the next owners. Davyhulme Hall had three storeys,
landscaped gardens and an artificial lake and was 'a modern mansion of no architectural
beauty', according to Langton. The estate was demolished in 1888, with Davyhulme Hall
Farm (*inset*) being one of the last estate buildings to be removed around 1930.

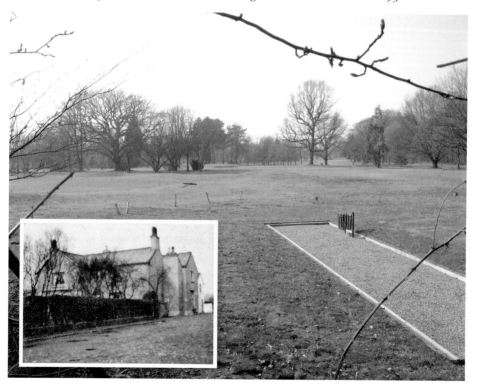

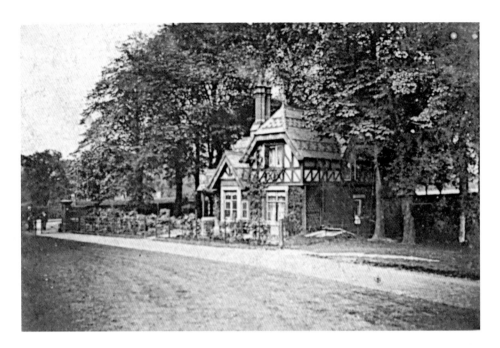

Entrance to Davyhulme Park Lodge, Davyhulme Road, Davyhulme, *c.* 1900
Constructed in 1883, the lodge became the ladies' clubhouse to Davyhulme Park Golf Club, founded in 1893, and home to the club steward. An additional pavilion was built at the same time. The lodge remained in use until 1937, when the new clubhouse was constructed. The golf club is the fourth oldest in England. In its grounds is an ornamental stone urn, commemorating the resting place of two racehorses that belonged to Robert Henry Norreys and were favourites of his.

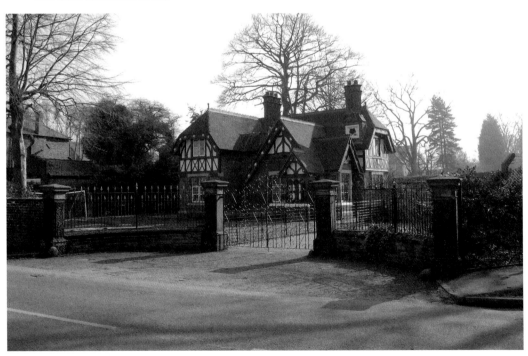

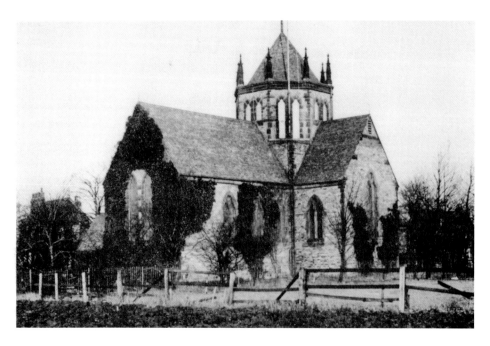

St Mary the Virgin, Davyhulme, Looking East, *c.* 1920, and Looking North, 2013
In 1887, Robert Henry Norreys died and the estate was left to his nephew, J. B. N. Entwistle. He gave the land to St Mary's church, whose foundation stone was laid on 13 July 1889. It was consecrated in 1890 and dedicated to his uncle and sisters, Mary Norreys and Isabella Bowers, who left a further £2,000 bequest. The architect was George Truefitt of London. An organ was installed in 1895, as well as eight bells in 1899, electric lighting in 1926, a vicarage in 1928, and a church hall in 1989.

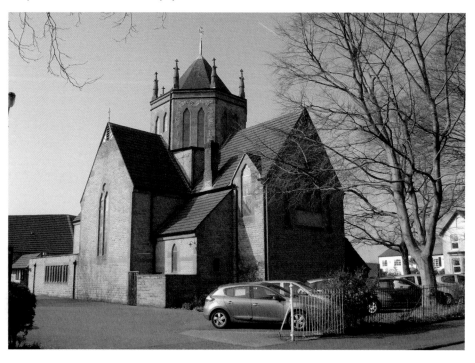

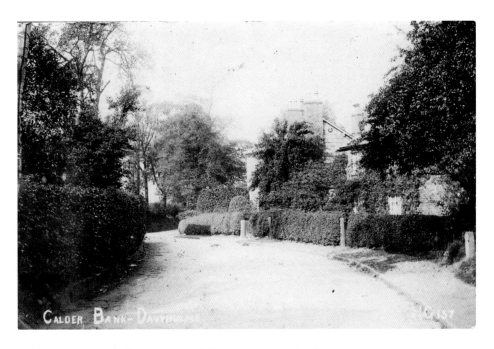

Calder Bank, Davyhulme, 1904, and the Fox & Hounds, Flixton, 2013
At the junction of Bent Lanes and Davyhulme Lane was a yew tree, under which John Wesley, founder of Methodism, once preached. Calder Bank is close to the Fox & Hounds public house (*inset*) at Woodsend. Formerly the Union Inn, it was originally a row of cottages (from around 1818), which belonged to Hulme's Bridge Farm and then the Flixton Union Society. The union liquidated in 1850, becoming a public house around 1861. Hulme's Ferry, beyond Union Cottages, replaced the bridge and recently reopened.

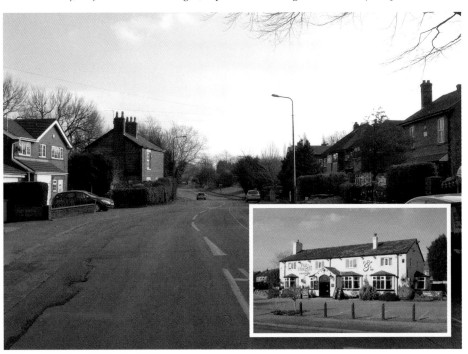

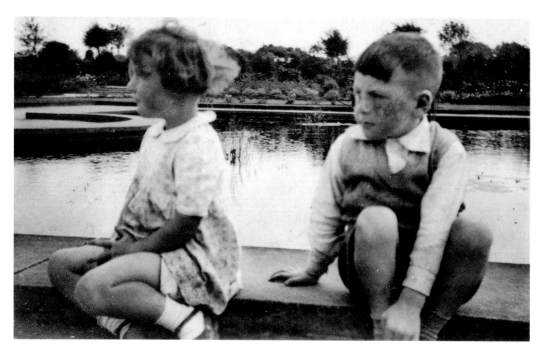

Barbara and Allen Cliffe, Davyhulme Park Ornamental Goldfish Ponds, c. 1945
This is the public park at the junction of Crofts Bank Road and Canterbury Road. The park's inception came in 1928 and it provided many facilities, from gardens and rockeries, including an ornamental pool with rock outcrops in the shape of England and Wales, to sports facilities. These included tennis courts and a bowling green. The park was surrounded by playing fields and its bandstand, in the form of a shell, was demolished in 1987 as it was deemed dangerous.

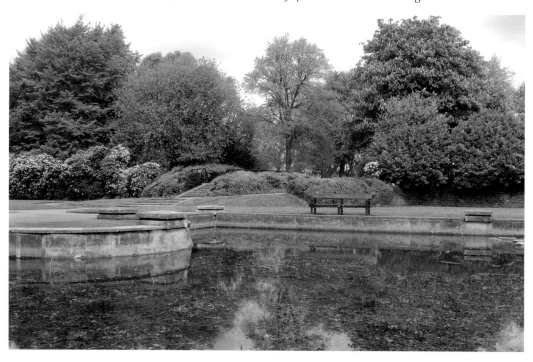

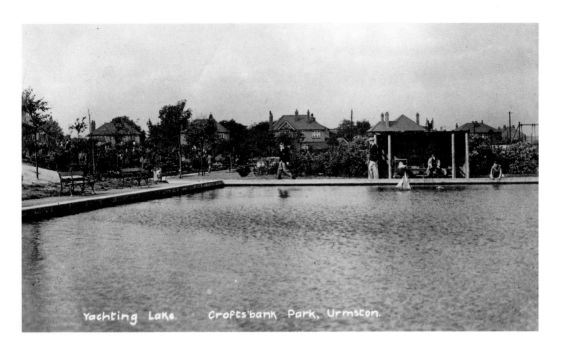

Yachting Lake. Crofts'bank Park, Urmston.

Yachting Lake at Davyhulme Park, *c.* 1940, and Barbara and Allen Cliffe, Davyhulme Park Ornamental Rockeries, *c.* 1945

Davyhulme Park's ornamental ponds were originally stocked with goldfish and there was a paddling pool for children, who could also sail model boats here, as shown in the photograph of around 1940. A playground, a sandpit and ornamental rockeries (*inset*) completed the facilities. In 1973, a new bowling pavilion was constructed and in July 1997, the paddling pool was drained and made into a play area. This is now a skate park, which has proved controversial because of its location.

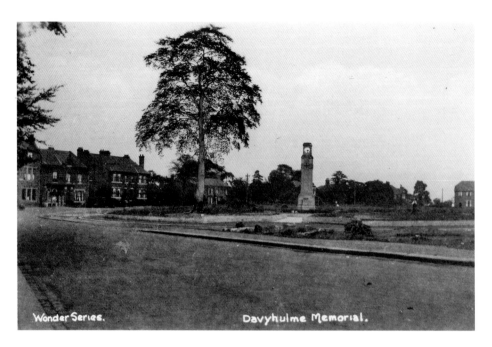

Wonder Series. Davyhulme Memorial.

Nag's Head Hotel and War Memorial, Crofts Bank, Davyhulme, *c.* 1929
The cenotaph at the Nag's Head Circle houses a clock, and was constructed in 1921, dedicated to the memory of those who lost their lives in the First World War. Originally located in the yard of Bethell's Farm, it was constructed before the circle, which was planned ahead of the cenotaph and opened in 1929. The circle has a circumference of 180 feet. Unfortunately, some names of those who fell in the Second World War are said to be missing from the memorial.

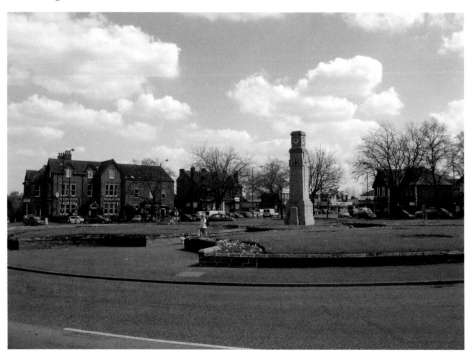

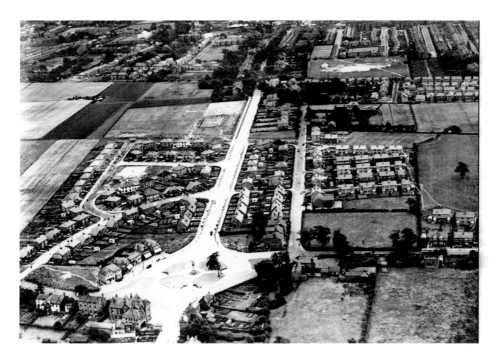

Aerial View of the Nag's Head Hotel, 1932, and Crofts Bank Road, Davyhulme, 1968
The Nag's Head Circle and Crofts Bank Road junction, briefly renamed Talbot Road in 1932, still has shops located on both sides of the junction, a pedestrian crossing in the foreground and a bus stop on the left (*inset*). Crofts Bank Road originally followed the course of Old Crofts Bank, the route of which runs parallel and to the right of Crofts Bank Road, as shown in the aerial photograph. The new section was constructed around 1896, hence the prefix 'Old' for the original route.

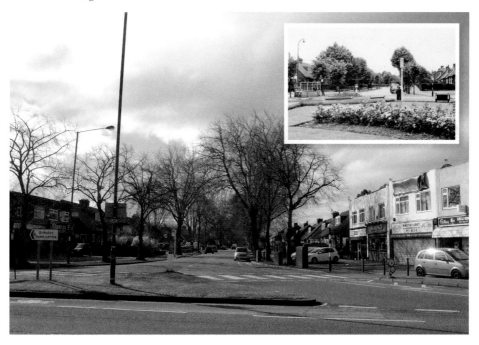

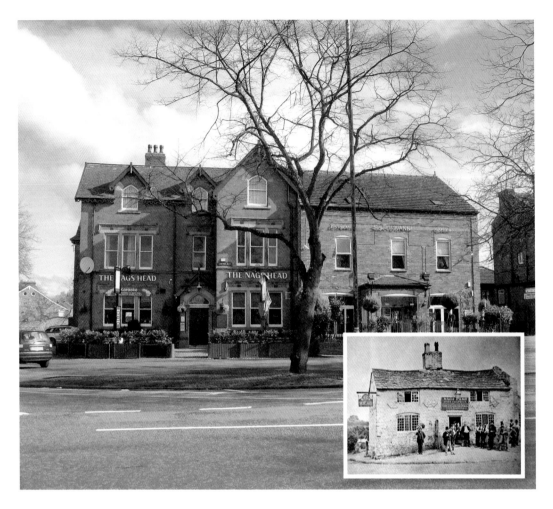

Nags Head Public House, Crofts Bank, Davyhulme, *c.* 1870
The Nags Head dates from the sixteenth century and was the size of a small cottage. It was demolished around 1870, to be replaced by the Victorian hotel, complete with upstairs function room. There was a bowling green to the rear, constructed around 1895 and destroyed by a bomb around 1940. It later became a car park, after being in a derelict condition for many years. There are still some original cobblestones from around 1870 along Barton Road. Rudyard's Farm was once situated here.

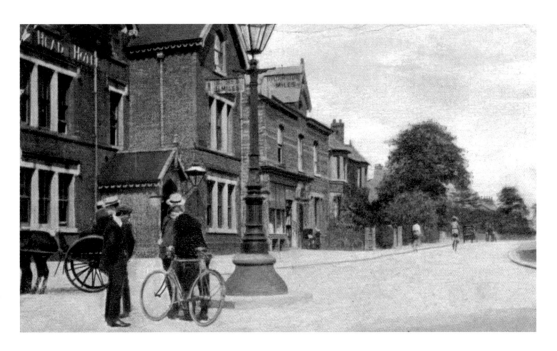

Crofts Bank and Lostock Road, 1905, and Lostock Hall Residential Hotel, Lostock Road, Davyhulme, *c.* 1930

Modern housing along Lostock Road first appeared in 1929, with the road and cycle tracks constructed in 1936. In 1905, the Nags Head Hotel, Faulkener's Grocery Store, Bella Vista, Glenluce and the Lindens (behind the trees) were located along Lostock Road. The Lindens was built in 1890, with Robert Estill and family moving there around 1901. Today, the same row shows the Nags Head Hotel, San Giovanni, Simpkins Dental Surgery, a retail development, Texaco petrol station and an office block, formerly Lostock Hall Residential Hotel (*inset*).

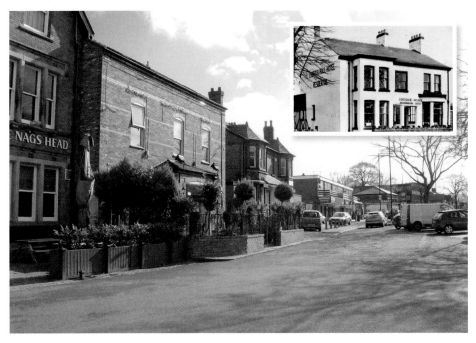

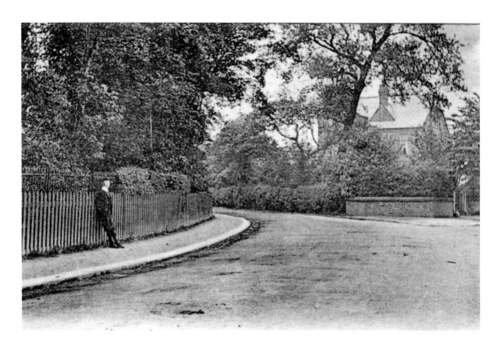

Haylands, 1903, and Crofts Bank Road, *c.* 1930

The *c.* 1870 Victorian mansion shown in the 1903 photograph is called Haylands, which is today a 'residential home for gentlemen'. The left-hand corner of this junction once belonged to Woodlands, now occupied by Urmston Social Club, formed in 1973. This location was originally an open area of land halfway along Old Crofts Bank, which became Woodlands in the 1890s and covered a site of 7 acres. Nearby Woodlands Close is named after the original dwelling.

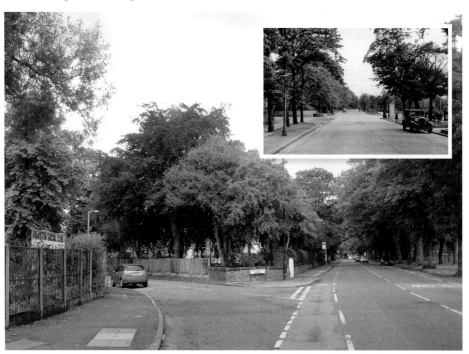

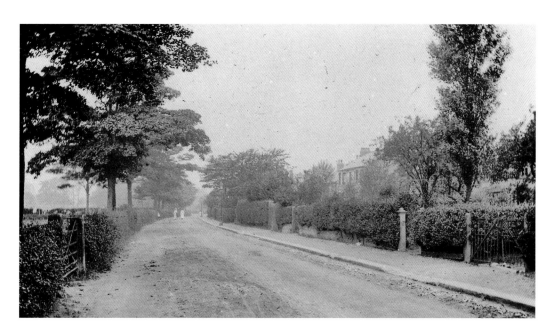

Davyhulme Lane (Road), 1912, and the Site of the Former Primitive Methodist Chapel and Endowed School, Davyhulme, 2013

Davyhulme Lane was the site of a Primitive Methodist chapel (1853) and an endowed school (1789). The old chapel was demolished around 1960, being replaced by a bungalow, with the school building now a private dwelling, both on the corner of Dalveen Avenue and Davyhulme Road. St Mary's National School replaced the endowed school on School Lane, now Cornhill Road, in 1880. The land was donated by Robert Henry Norreys, of Davyhulme Hall.

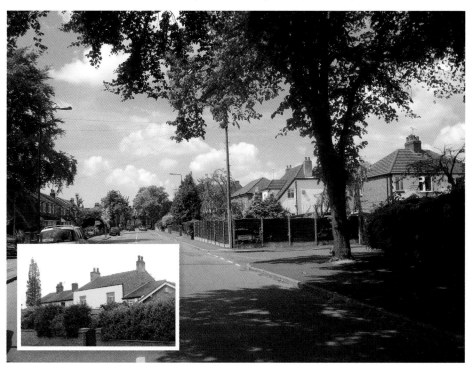

Steven and Diane Dickens, No. 24 Broadway, c. 1969, and the Cliffe Family, 1959
Longford Brook began in Stretford, ran parallel to Barton Road and Kingsway Park, then continued beneath the Crofts Bank culvert bridge and alongside Broadway, marked by the line of trees behind the car in the 1969 photograph and on the right of the modern photograph. Piped in 1955 and 1962, it became the Bent Lanes Brook at Red Lane (Woodhouse Road), behind the Bent Brook public house, built around 1962 and eventually drained into the River Irwell, near Davyhulme Sewage Works, built around 1880.

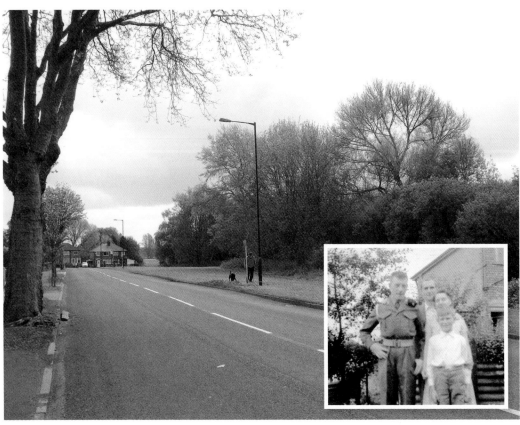

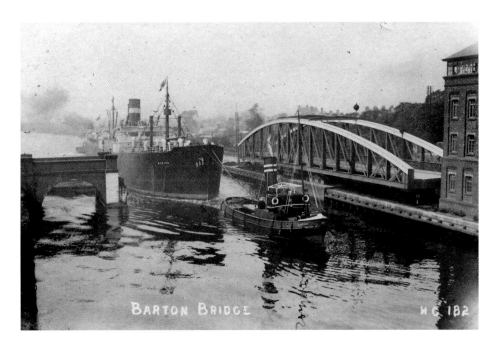

BARTON BRIDGE H C 182

Barton Swing Bridge and the Manchester Ship Canal, Redclyffe Road, Barton, *c.* 1900
Constructed around 1893, the whole complex of the bridge, aqueduct and control tower was
Grade II listed in 1987. The engineer was Sir Edward Leader Williams (1828–1910), with
Andrew Handyside & Co. providing the materials. It weighs 800 tons, is 195 feet long and
25 feet wide. It has a sixty-four-roller hydraulic system, enabling it to revolve on a central
axis and allowing the passage of ships. These often expanded in heat, causing the structure
to lock and the travelling public to be 'bridged'.

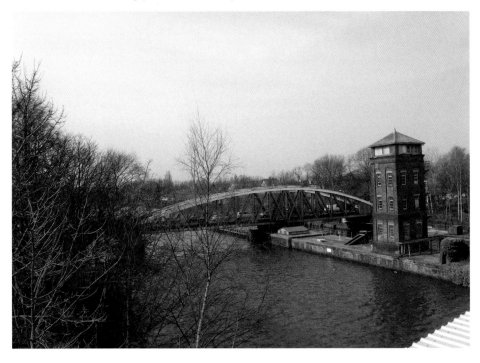

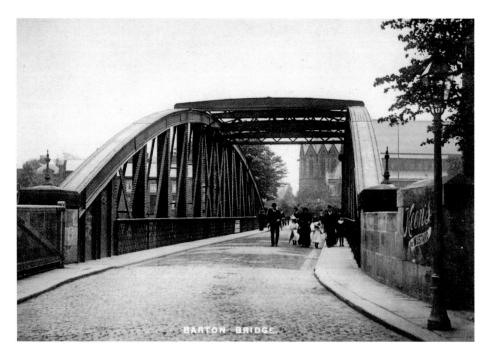

Barton Swing Bridge and All Saints Roman Catholic Church, Barton, *c.* 1900

All Saints was established in 1789, the present building being designed in 1867/68 by Edward Welby Pugin (1834–75). The church is Gothic Revival in style, with a distinctive steep sloping roof and a bell turret to the west. All Saints, listed as Grade I in 1978, is also the centre for a Franciscan Friary. The Presbytery, also Pugin's work, was Grade II listed in 1978. Sir Humphrey de Trafford established the church in an attempt to build a Catholic congregation in Barton.

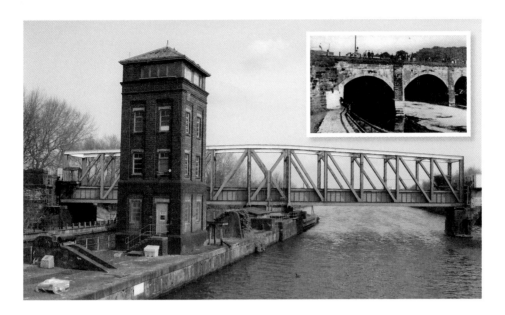

Barton Aqueduct, Bridgewater Canal, Barton, and John Dickens Gulf Oil Ltd, Barton Oil Terminal, *c.* **1960.**

The inset shows the original stone construction over the River Irwell shortly before demolition, around 1891. The crossing was originally undertaken by ferry boat around 1586, with the first bridge constructed in 1681 and repairs undertaken in 1746. Before the new aqueduct was built, shipping was limited by the size of the bridge's arches, and only barges known as 'Mersey Flats' were able to negotiate the sometimes treacherous channels. Originally Chapel Place, Barton Oil Terminal (*below*), was developed on the right of the modern photograph, next to the new aqueduct.

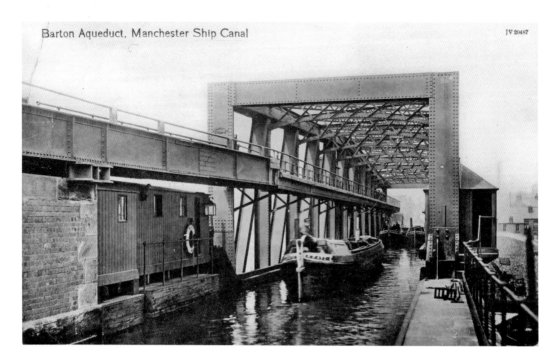

Barton Swing Aqueduct, Bridgewater Canal, Redclyffe Road, Barton, 1914
At 235 feet long and weighing 1,450 tons, the bridge swings on a central axis to allow the passage of ships. The aqueduct takes the form of a boxed lattice girder, containing an upper section, the channel remaining full of water when turning. James Brindley (1716–72) designed the Bridgewater Canal, his stone aqueduct being built around 1761 and replaced around 1891. There are remains of this aqueduct preserved on the Eccles side of the Manchester Ship Canal and marked by a plaque.

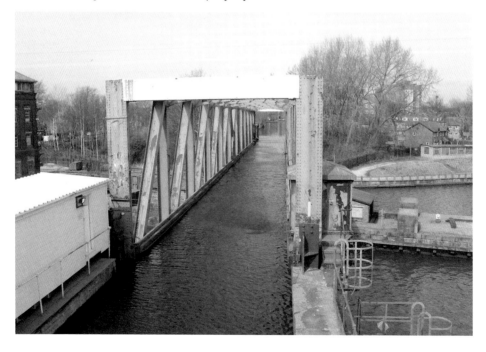

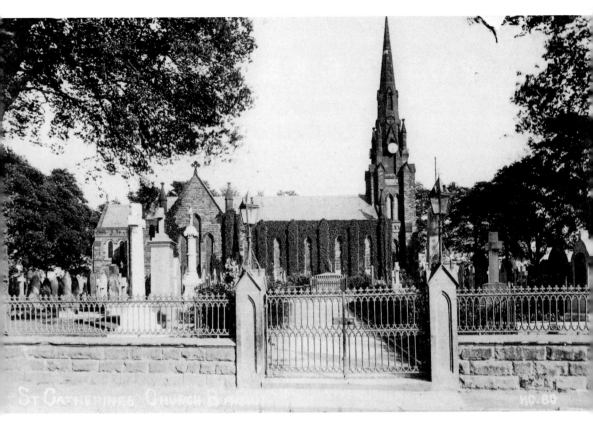

St Catherine's Church, *c.* 1900, Interior of St Catherine's Church, 1 October 1960
The foundation stone for St Catherine's church was laid by Lady de Trafford on 22 July 1842 and the church was consecrated on 25 October 1843. It had an unusual 100-foot-high octagonal spire and a peal of bells, scrapped around 1960. The church was demolished in 1973 due to dry rot, but its graveyard still exists, now under the jurisdiction of Barton with Peel Green parish. Marshall Stevens, founder of the Manchester Ship Canal and developer of Trafford Park Estates, is buried here.

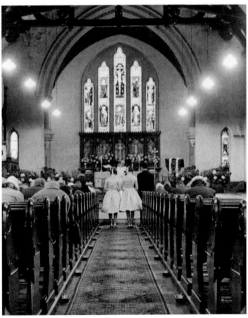

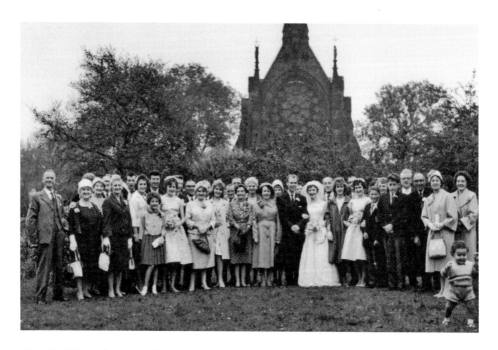

The Wedding of John Dickens and Barbara Cliffe at St Catherine's Church, Old Barton Road, Barton, 1 October 1960

St Catherine's church served the Church of England parish of Barton-upon-Irwell, and was located alongside its neighbour, All Saints Roman Catholic church. All Saints is shown in the photograph of 1 October 1960, behind the wedding party standing in the grounds of St Catherine's church. The church was originally located in the districts of Bromyhurst and Dumplington, its parish being Eccles until 1867. The land for St Catherine's construction was donated by Sir Thomas de Trafford.

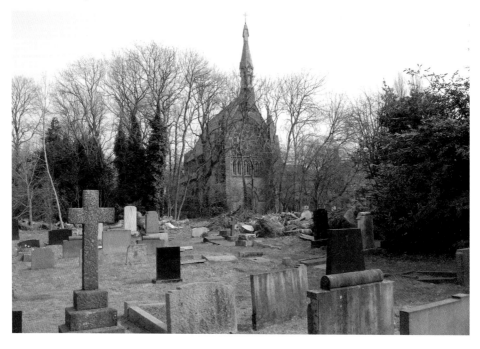

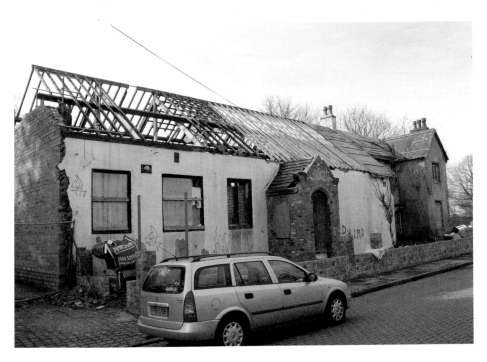

The Old Schoolhouse, Old Barton Road, Barton, Spring and Autumn, 2013
The old schoolhouse falls within the boundaries of the Barton Conservation Area. The building was still being used as a Church of England schoolhouse in 1940 but was in existence well before this date. It was usual for the school headmaster to live in the adjoining cottage, which once had a date plaque of 1846 over the front door. The old schoolhouse, which was in a particularly dilapidated condition, is now undergoing some reconstruction, as shown in these 2013 photographs.

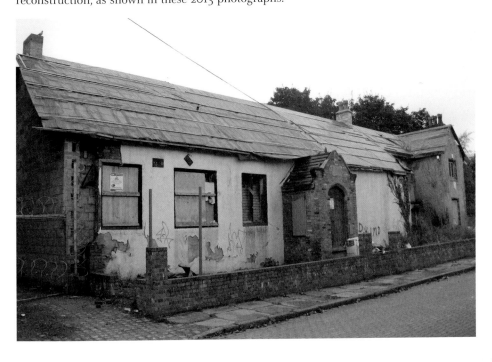

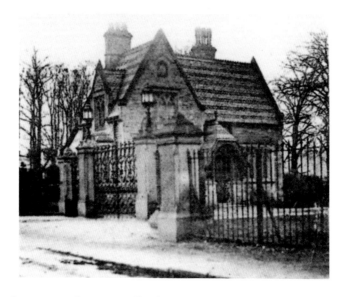

The Barton Entrance Lodges to Trafford Park Hall and Estate, Redclyffe Road, *c.* 1890, and Trafford Park Hall and Estate, Barton, 1896

Barton entrance lodges were originally sited on the banks of the Bridgewater Canal, but were moved to Dumplington Lane, now Redclyffe Road, in the nineteenth century (on the right of the modern photograph), and were demolished around 1920 when Barton power station was built. In 1896, the de Trafford family sold Trafford Park Hall and Estate (*inset*) to Ernest Terah Hooley, who then formed the Trafford Park Estates Company. The hall was demolished around 1946, after it was damaged by bombing in 1940.

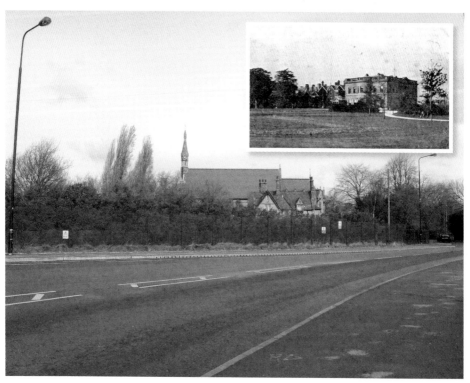

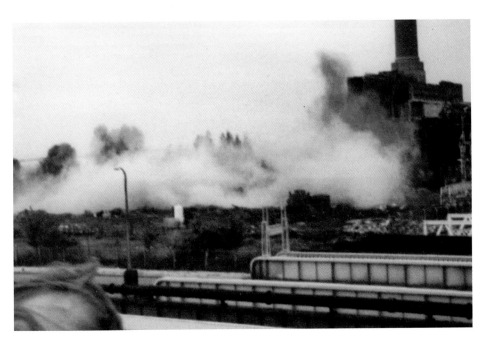

Demolition of Barton Power Station Chimneys, Redclyffe Road, Barton, 1979
A power station was first proposed in 1914 and built in 1923, its distinctive twin chimney stacks being added in 1933. These replaced the multiple lower level chimneys of the original power station. Barton power station closed in 1973 and was demolished in 1979. The series of pictures were taken from the oil storage tank nest of Gulf Oil Ltd, on Ashburton Road West, by my father, John Dickens. The site is now occupied by B&Q.

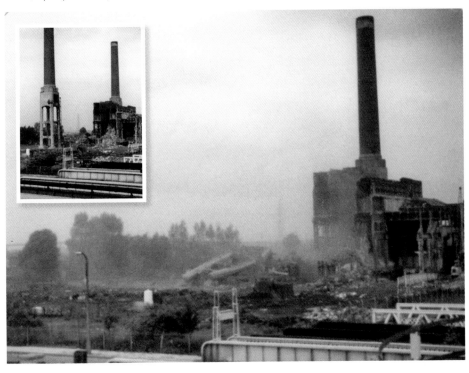

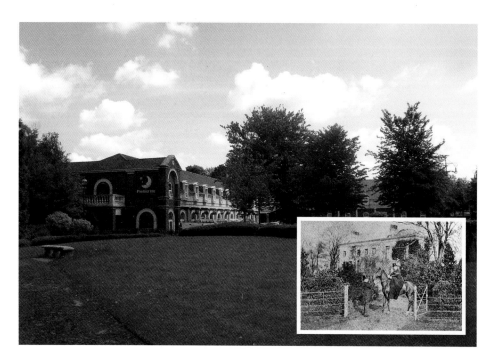

Wilderspool House, Wilderspool Woods, Davyhulme, *c.* 1890, and Dumplington Lane, Barton, 1915

Today Dumplington, between the Nags Head and Barton Bridge, is known as Ellesmere Circle and Trafford Boulevard. In 1890, the area was known as Wilderspool Woods, with Redclyffe Road known as Dumplington Lane. The woods formed the grounds of Wilderspool House, which was demolished in 1963, with the land becoming part of a farm until 1967/68. The site later became the Trafford Centre's Premier Inn. For a while, a portion survived with a pond, around which we used to ride our bikes when we were children!

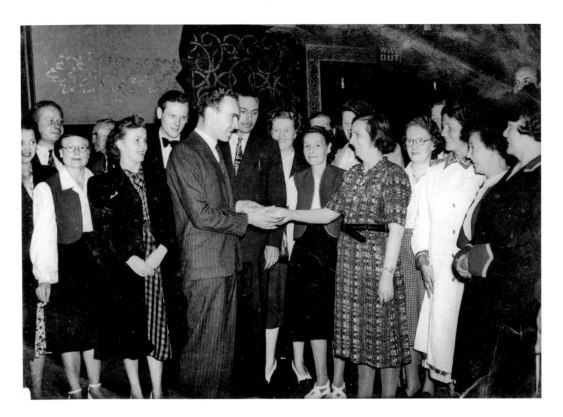

Foyer of the Empress Cinema, Higher Road, Urmston, *c.* 1953
My grandmother, Jessie Cliffe, stands on the left of the lady shaking hands. Jessie was an usherette at the cinema in the 1950s and is wearing a typical uniform of that era. This consisted of a green tunic waistcoat, a white blouse and black skirt. My mother, then Barbara Cliffe, recalls that she used to receive a pass enabling her to see films for free! The Empress closed on 11 October 1958 and was demolished in 1962, being replaced by a retail development.

About the Author

Steven Dickens is a resident of Flixton. He has published several journal and magazine articles on the local history of Flixton, Urmston and Davyhulme, and is also the author of *Sale Through Time*. Steven is a retired charge nurse and college lecturer, with an academic background in modern history. He is married to Sarah, and they have three sons and three daughters.

Bibliography

Cheshire Record Office, Chester.

Cliff, K., and V. Masterson, *Images of England. Urmston, Flixton and Davyhulme* (Stroud: Tempus, 2000).

Crossland, A., *Looking Back at Urmston Including Flixton & Davyhulme* (Altrincham: Willow, 1983).

Dickens, S., 'David Herbert Langton' (1858–1918) Author of *A History of the Parish of Flixton* (1898), Parts One & Two, *The Manchester Genealogist*. Vol. 49. Nos. 3 & 4, 2013.

Dickens, S., *A Short History of Gulf Oil (Great Britain) Ltd., at the Barton Oil Terminal. The Ashburton Road West Plant, Manchester, 1902–1979*, Trafford Park Heritage Centre Archive, Manchester (Archive Ref. No. E326).

Dickens, S., 'The Roles of William and John Henry Royle in the Development of Pool Plat, Flixton, parts One to Eight', *The Manchester Genealogist. Member's Articles*, March 2011 (www.mlfhs.org.uk).

Dickens, S., 'Victorian Morality and the Clergy. The Reverend Richard Marsden Reece MA, Rector of the Parish Church of St Michael, Flixton, 1873–1906', *The Manchester Genealogist*, Vol. 44. No. 1. 2008, pp. 23–31.

Harrison, W., 'Ancient Fords, Ferries and Bridges in Lancashire', *Transactions of the Lancashire and Cheshire Antiquarian Society. Vol. XII 1894* (Manchester: Richard Gill, 1895), pp. 1–30.

Lancashire Archives, Lancashire Record Office, Preston.

Lancashire Census Returns, William Hallsworth, No. 9 Flixton Road, Urmston, 1881 (RG11 3889/40 No. 15).

Langton, D. H., *A History of the Parish of Flixton, comprising the Townships of Flixton and Urmston, with a short sketch of the adjoining Hamlet of Davyhulme* (Manchester: Taylor, Garnett, Evans & Co., 1898).

Lawson, R., *A History of Flixton, Urmston and Davyhulme* (Urmston: Richard Lawson, 1898).

Lee, D. W., *The Flixton Footpath Battle* (Peak & Northern Footpaths Society, 1976).

Leech, D. J., 'Flixton and its Church', *Transactions of the Lancashire and Cheshire Antiquarian Society. Vol. IV 1886* (Manchester: A. Ireland & Co. 1887), pp. 182–199.

Manchester Archives and Local Studies, The Manchester Room@City Library (Local Studies), Elliot House, Manchester. Photographs courtesy of Manchester Libraries, Information and Archives, Manchester City Council.

Potts, B., *Reminiscences of a Flixton Boyhood, 1936–1954* (Swinton: Richardson, 1986).

Proceedings., 'Ancient Boat found in Ship Canal', *Transactions of the Lancashire and Cheshire Antiquarian Society. Vol. XII 1894* (Manchester: Richard Gill, 1895), p. 119.

Royle, C., *This Was My Village. Boyhood Recollections of Flixton, 1922–1938* (Swinton: Richardson, 1994).

Slater's Directory of Manchester, Salford & Suburban Directory for 1903–1919 (Manchester: Slater's Directory Ltd, 1903–1919).

Smith, D., *An Alphabetical History for the Urmston Urban District*. Spring 2013 (www.urmston.net)

Trafford Lifetimes (http.//www.trafford.gov.uk).

Trafford Local Studies Centre, Sale Library, Sale. Photographs reproduced with the kind permission of Trafford Local Studies.

'Urmston Tramway Difficulty: Terms of a Suggested Settlement', *Manchester Guardian*, 30 January 1905, p. 8.

Yates, G. C., 'Bronze Implements of Lancashire and Cheshire', *Transactions of the Lancashire and Cheshire Antiquarian Society. Vol. XIII 1895* (Manchester: Richard Gill, 1896), pp. 124–42.